D0895358

COLLEGE
NTERS

WITHDRAWN

WHY MONA LISA SMILES
AND OTHER
TALES BY VASARI

WHY MONA LISA SMILES AND OTHER TALES BY VASARI

Paul Barolsky

THE PENNSYLVANIA STATE UNIVERSITY PRESS
University Park, Pennsylvania

ALSO BY PAUL BAROLSKY

Michelangelo's Nose: A Myth and Its Maker
Walter Pater's Renaissance
Daniele da Volterra: A Catalogue Raisonné
Infinite Jest: Wit and Humor in Italian Renaissance Art

Library of Congress Cataloging-in-Publication Data

Barolsky, Paul
 Why Mona Lisa smiles and other tales by Vasari / Paul Barolsky.

 p. cm.
 Includes bibliographical references and index.
 ISBN 0-271-00719-2
 1. Vasari, Giorgio, 1511–1574—Criticism and interpretation.
 2. Art, Renaissance—Italy. 3. Art, Italian. I. Vasari, Giorgio,
 1511–1574. Vite de' più eccellenti pittori. II. Title.
 N7483.V37B36 1991
 709'.2—dc20 90–7506

Copyright ©1991 The Pennsylvania State University
All rights reserved
Printed in the United States of America

It is the policy of The Pennsylvania State University Press to use acid-free
paper for the first printing of all clothbound books. Publications on uncoated
stock satisfy the minimum requirements of American National Standard for Infor-
mation Sciences—Permanence of Paper for Printed Library Materials, ANSI
Z39.48–1984.

*For Sydney Freedberg and Cecil Lang
in the living spirit of Morto da Feltro*

On Vasari's foxed page my hand is warm.
*　　　—Josephine Jacobsen, "Reading on the Beach"*

CONTENTS

Preface xiii
Acknowledgments xv

Who Was Vasari? 3
The Artist as Hero 5
A Dantesque Fantasy 8
The ABCs of Giotto's O 10
Goffism 13
Words in Pictures 14
Frozen Words 16
Mock Devils 17
Pleasurable Deceits 19
Buffalmacco's Ape 20
Crowns of Fish 22
Rosy Cheeks and Bad Breath 23
Nothing but Cheese 24
The Fake Painter 25
Michelangelo's Advice on Fashion 26
Gherardi's Cloak 28
Haberdashery as Farce 29
Novella into Biography 30
The Fable of Castagno 32
Zuccone as Idol 33

Pygmalion and Medusa 34
Playing on Petrarch 35
Living and Dead Stone 37
Raphael and Laura 38
The Philosophy of Nomenclature 39
What's in a Name? 42
Noble Names 44
Spinello and Spinelli 45
Litigious Lippo 46
Nicknames 48
Rabelaisian Play on Names 50
Uccello's Birds 51
Wordplay 53
Love of Language 55
Ingenuity and Ingenuousness 56
The Life of Morto da Feltro 58
Leonardo's Lost Lion 60
Why Mona Lisa Smiles 62
Mona Lisa at Court 64
A Great Woman 65
Pontormo's Most Beautiful Painting 66
The Meaning of Pontormo's *Joseph* 67
Fathers and Sons 69
Margherita's Oration 70
Vasari's Wives 71
Penelope and Lucretia 73
A Dantesque Perspective 74
Of Patriarchs and Patricians 75
Joseph and Pharaoh 76
The Siege of Florence 77
The Book of the Artist 79
Vasari and "Vasari" 81
Petrarch and Arezzo 82
Pietro and Giorgio Aretino 83
The "Real Life" of the *Lives* 84
Vasari's Family Mausoleum 86

Arezzo Aggrandized 88
An Aretine Jest 90
The Resurrection of Lazzaro 91
A Childhood Memory 93
I Made, I Said 93
Vasari at Court 94
The Return of Buffalmacco 96
Vasari's Revenge 97
You and Thou 99
Vasari to the Rescue 100
A. M. V. G. 101
Parallel Lives 104
The Medici Triumphant 106
History and Novel 108
Vasari's Banquet 112

Bibliographical Essay 117
Selected Bibliography 123
Index 125

PREFACE

For over twenty years it has been my privilege to teach Vasari's *Lives* of the artists to students ranging from college freshmen to graduate students in art history and literature. Vasari is accessible to those seeking to learn about the Renaissance for the first time because he is above all a lively and entertaining writer who engagingly tells us about the world in which he lived. He is also of considerable interest to scholars of the period because of his deep, intimate, and sophisticated understanding of Renaissance art, of its theory and practice. This book is written for both kinds of readers. Initiates can learn much about the Renaissance from Vasari's vivid, often impassioned and witty biographies of artists, from his playful fictions and anecdotes, many of which are interpreted in the following pages. Beginners may read this book as a commentary on the *Lives;* it is a gloss to a book even more interesting, as we shall see, than it already appears to be. My book is, at the same time, addressed to scholars of Renaissance culture: art historians, historians of ideas, politics, and society, and literary historians, all of whom already know Vasari, who even use him as a primary source. For these more sophisticated readers I present what follows as a revisionary reading of Vasari—a reading that, built on the foundations of a vast scholarship on Vasari, attempts to argue that his *Lives* is a much more subtle and complex work of both history and imaginative literature than has been previously supposed. I make this latter point more fully in the bibliographical essay at the end of the book, which the nonprofessional reader may blithely ignore.

The reader will not find works of art illustrated in the following

pages, both because such images are unessential to my argument and, more important, because I want to emphasize, in contrast to the conventional view, that Vasari's book stands in its own right, on its own terms, as a great work of art, as a masterpiece of imaginative literature—not just as an appendage to the history of art it describes. I ask the reader to focus here on the universe of Vasari's imagination, which poetically gives form to the spacious world it englobes. Let us turn here to the artistry not of those whom Vasari celebrates, but to the poetry that informs his own sympathetic vision of humanity—to the allure and fascination of his stories. Let us read Vasari as we read Castiglione, Rabelais, and Cellini, above all, as a great writer!

ACKNOWLEDGMENTS

I wish to thank here those friends and colleagues who helped me with their advice, suggestions, ideas, encouragement, or with other kindnesses. They included the following: Anne Barriault, Bonnie Bennett, David Carrier, Bruce Cole, Philipp Fehl, Jessica Feldman, Claire Farago, Lydia Gasman, Larry Goedde, Cherene Holland, Walter Kaiser, Joy Kenseth, Andy Ladis, Norman Land, Jim Marrow, James Mirollo, Gail Moore, Tom Roche, Pat Rubin, Kathy Schrader, Sylvia Strawn, and Philip Winsor. In particular, I am grateful to Ralph Lieberman and David Summers, who in the course of numerous, long letters and walks, have tolerantly heard more of Vasari's stories retold and interpreted than they might otherwise have wished. They have been patient friends.

Cecil Lang is largely responsible for whatever is clear, precise, and persuasive in my prose. If there is a nice turn of phrase here and there, it is inevitably attributable to him. Sydney Freedberg's deep scrutiny of sixteenth-century artifice underlies more than a little of what follows, even though this claim might bring an ironic smile to his lips. In many ways this is Cecil Lang's and Sydney Freedberg's book—hence my dedication of it to them. Finally, and, as ever, I have depended on the sustained affection of my wife, Ruth, and children, Deborah and Daniel, who humored me when I boldly announced that I, and I alone, knew why Mona Lisa smiles.

WHY MONA LISA SMILES
AND OTHER
TALES BY VASARI

Who Was Vasari?

Every year hundreds of thousands of tourists who travel to Florence visit the Uffizi, the museum that houses the famous collection of paintings ranging from Cimabue and Giotto through Leonardo, Raphael, and Michelangelo. Few of these visitors know that the Uffizi was built in the middle years of the sixteenth century by one of the most accomplished architects of the day, Giorgio Vasari. He built this structure for Duke Cosimo de' Medici as the administrative and judicial offices of the city, hence the name "Uffizi" for offices. As architect and also as prolific painter at the courts of the Medici in Florence and of the popes in Rome, Vasari is known almost exclusively to specialists in Italian Renaissance art. The typical visitor to the Uffizi or to any other major museum or church does not go in search of works by Vasari—although it must be said that Vasari was a noted and successful painter in his day.

Many tourists who visit the Uffizi do, however, know Vasari's *Lives* of the artists, first published in Florence in 1550, a few years before he built the Uffizi. Vasari's book celebrates the history of art from Cimabue and Giotto to Michelangelo and, in the revised, amplified edition of 1568, Michelangelo's contemporaries, including Vasari himself. When the Uffizi was made into the home of the state collection of Renaissance masterpieces in the nineteenth century, it became the aesthetic shrine of the very history of art first given definition by its builder, Vasari. Vasari's canon of great works was thus enshrined in a building of his own design, now a modern temple dedicated to the history of art as he had initially conceived it.

The *Lives* is widely known as the first monumental history of art, and Vasari is appropriately called the father of art history. All those who have written histories of art since him, from Bellori and Winckelmann to the professional art historians of our own day, write as his

followers. Even those who do not know much about the history of art or care much about it, however, know Vasari. If they have heard the story of how Leonardo died in the arms of the king of France, for example, and if they have read Robert Browning's fictionalized poetical soliloquies based on the lives of Fra Filippo Lippi and Andrea del Sarto, they know Vasari. The very myth of Michelangelo's divinity as well as the famous stories of his raging conflict with Pope Julius II can be traced back to the pages of Vasari.

To know Vasari, as we know, say, Plato, Saint Paul, Machiavelli, Rousseau, or Freud, it is not necessary to have read him. Long before the Romantics cultivated the artist's self or before Freud, in their wake, probed the artist's psyche, Vasari wrote tales about the foibles and eccentricities of artists that have become legendary. Vasari linked the creativity of his artists to their idiosyncrasies, in conformity with a conventional Renaissance theory of art, which prized strangeness or novelty of invention. It was less Vasari's learned, sometimes pedantic discourses on art theory that were remembered than his fictions— whether the tale of Giotto painting a fly on the nose of a Christ by his teacher Cimabue or the story of Baccio Bandinelli tearing up Michelangelo's cartoon for the *Battle of Cascina* in a fit of envious rage. Almost all of these stories are fictions, most of Vasari's own invention, and they have left their impress on the imaginings of those in the modern period who have pondered the myth of the artist.

For professional art historians Vasari's tales are often an irritant, since such fictions are said to be remote from the "true history" of art. I have argued in *Michelangelo's Nose*, however, to which this book is a sequel, that Vasari's tales are never mere fiction, because such fictions tell us a great deal about how Vasari imagined "reality," which is part of the historical record. Knowing how to read Vasari, we come to see just how much history is poetically embedded in his tall tales.

Vasari has endured primarily because of his extraordinary gifts as a storyteller, as a teller of tall tales. His Filippo Lippi, Fra Angelico, and Piero di Cosimo, his Leonardo, Raphael, and Michelangelo, the subjects of his anecdotes and fictions, are three-dimensional and as vivid as any characters in the pages of Boccaccio or Chaucer. Because Vasari's characters are real people, we sometimes conveniently tend to ignore the fact that most of what Vasari tells us about them is in the form of fiction. We want to believe in their "reality." We want to believe that what he says about them is so.

And believe in them we do, because of Vasari's literary gifts. Even the "scientific" art historian slips into believing Vasari's tales, unwittingly suspending disbelief in the process. We fall under the spell of a writer, whose book is more than a sequence of biographies containing "novelle." Vasari's book, as I will eventually show, is incipiently a historical novel, an autobiographical novel, in which "Giorgio Vasari" is an idealized, fictionalized protagonist. When we read Vasari as a novelist, we discover an imaginative writer of unexpected and uncommon range and depth. When we read him not merely as an art historian but as a literary artist in his own right, we begin to see more clearly, to understand why Vasari's book is not just about art but is itself a masterpiece of Renaissance fiction. We see why Vasari is not the "prosatore minore" or minor prose writer that he has sometimes been called; we discover why it is that Vasari is a great artist.

What follows is not a systematic and exhaustive study of Vasari's *Lives* (in the revised version of 1568) but an essay, a guide to some possible ways of approaching his book. For this reason it seems inappropriate to burden the reader with detailed citations and footnotes. My principal sources in the Vasari literature are provided in the Bibliographical Essay and accompanying Selected Bibliography. My goal here is not to send readers off to the secondary literature but directly to Vasari himself. It is not my purpose to have readers dwell only on specific passages in Vasari. Rather, I hope that they will be encouraged to read the *Lives* in its entirety and thus to see structures and themes they would otherwise have missed.

The Artist as Hero

Fra Filippo Lippi, nearly driven mad by carnal urgency, flees from the Medici Palace, whereas Fra Angelico sheds a tear and offers up a prayer, painting a Crucifixion nearby at San Marco. While the loving Domenico Veneziano is painting works both colorful and delicate, the bestial Andrea del Castagno, fired by envy, plans to murder his fellow artist. When a patron refuses to pay him adequately, Donatello flies into a rage and throws his work to the ground, smashing it to smithereens. Brunelleschi, when asked how he is going to support his giant dome for the cathedral of Florence, gracefully puts down a broken egg

on its bottom, as if to say, "like this." Paolo Uccello is so lost in studies of his "sweet perspective" that he does not come to bed when called by his wife, and the strange Piero di Cosimo, painter of bizarre fantasies, is terrified by thunder and irritated by the laughter of children. Lust, devotion, and treachery, rage, wit, obsession, and eccentricity—these are the unforgettable themes of Vasari's *Lives* of the artists. They are unforgettable because Vasari's tales about his artists are unforgettable, and his tales are unforgettable because Vasari is a great writer, a great artist.

Vasari's stories are tales of struggle and conflict—of artists battling other artists in fierce competition, warring against their patrons, struggling like titans against their very selves. Michelangelo is the supreme example of such conflict—at war with himself, with his sense of his own sinfulness, pitted against his impetuous patron, Julius II, struggling mightily against his hateful adversaries. When Rainer Maria Rilke wrote a tale in *Stories of God* about Michelangelo struggling with the very medium and subject of his art, making an image in stone of God that terrifies God himself, he wrote a story that freely embellishes Vasari's portrayal of Michelangelo's terrifying art and person. Rilke's highly imaginative image of Michelangelo is related to Merejkowski's re-creation of Vasari's Leonardo in *The Romance of Leonardo da Vinci* (which held Freud spellbound), to D'Annunzio's evocation of Vasari's Giorgione in *Il Fuoco*, to George Eliot's revivification of Vasari's Piero di Cosimo in *Romola*.

Vasari's artists are present in modern fiction even when unnamed. There is, for example, more than a little of Vasari's Leonardo in Balzac's Frenhofer of *Le Chef-d'oeuvre inconnu*. Balzac's protagonist, an obsessive perfectionist who cannot finish his masterpiece, is a fantastic exaggeration of the unrelenting Leonardo, who leaves his works unfinished, aspiring to achieve perfection, to render the impossible. So, too, when Zola has Claude Lantier paint his dead son in *L'Oeuvre*, he echoes, consciously or not, the moment in Vasari's life of Signorelli when the artist paints his dead child. In both fictions, the authors demonstrate their artists' heroic dedication to their art in the face of adversity.

Vasari's artists, portrayed in more than one hundred and sixty biographies in the 1568 edition of the *Lives*, are the ancestors of all those artists (painters, sculptors, poets, novelists, and composers)

who are the heroes of modern stories and novels by Balzac, the Goncourts, Hawthorne, Zola, Pater, James, Cather, and Maugham. In the canon of twentieth-century fiction, Joyce, Proust, Mann, and Kafka have perfected this subject as a paradigm of literary modernism: the artist's education, his struggles, both internal and external, his heroic aspiration to give meaningful form to his vision in a chaotic and hostile world. If Balzac and Zola are the romantic forebears of these modernist fictions celebrating the heroic lives of artists, Vasari's tales are the background. In the mansion of modern imaginative literature, wherein the artist as hero resides, Vasari's *Lives* are the very foundation. When we look again at his artist-heroes, whose fictitiously re-created lives are dedicated so faithfully and fully to art, we see that his book is a crucial, highly influential, and enduring monument in the history of literature which celebrates the artist's struggles and triumphs. We do not see the like in Plato or Plutarch, in Virgil or Ariosto, in Augustine or Abelard. Vasari's artists are the ancestors of James's Roderick Hudson, of Proust's "Marcel," of Mann's Leverkühn, of the Joycean "artist as a young man," of Kafka's "Hunger Artist." This point, though an obvious one, needs to be made, since Vasari remains on the margins of the history of literature as it is currently written.

Although it is a commonplace that the artist himself is a central subject of modern literature, either literally or metaphorically, Vasari's sustained influence on this theme is virtually undiscussed by scholars of modernist literature—notwithstanding the standard acknowledgment of Vasari's place in Browning's poetry. Even in the field of Renaissance literature it is exceptional for scholars of comparative literature to write about Vasari and, when they approach him, they do so by commenting on his definition of the Renaissance, on his place in the history of Mannerism, or they analyze philologically his theoretical, technical, and rhetorical language. Vasari remains a prisoner within the boundaries of genre. Since he is a biographer, historian, and theorist, we fail to surmise, even dimly, his full contours as an imaginative writer of fiction, as a poet, whose work is part of the stream of imaginative literature in the modern period. We fail to see him properly as a master storyteller in a tradition extending from Boccaccio to Proust. Where in the vast literature on narrative, where in narrative studies, do we find Vasari? Nowhere! He remains an exile

from the history of imaginative literature—an exile from the very history to which he contributed so much.

A Dantesque Fantasy

The Italian art historian and prose stylist Roberto Longhi used to say to his students, "Bisogna sapere come leggere il Vasari"—one must know how to read Vasari. By this he meant that an understanding of Vasari's rich, critical vocabulary of technical terms yields insight into the aesthetics of Italian Renaissance paintings: Vasari's vocabulary, rightly understood, teaches us how to look at Italian painting. Longhi's advice can be construed more broadly to mean that if we read Vasari's book not just as a critical lexicon or as a historical source but as an imaginative work, we discover in it an unexpected world of fantasy. When we do this, dwelling on Vasari's fictive powers, we begin to understand why it is that Vasari is ubiquitous in modern fiction and poetry.

Vasari is forever returning to Dante, looking at particular works of art, indeed the entire history of art, through the lens of the *Divine Comedy*. Dante's poem is part of his and his contemporary reader's mental furniture; it becomes the fictive world in which Vasari places the true story of the history of art. In three consecutive cantos of *Purgatorio*, Dante discusses painting and sculpture: in Canto X he describes three monumental relief sculptures that surpass the manner of Policlytus; in Canto XI he says that Giotto surpassed Cimabue, as the miniaturist Franco of Bologna had surpassed Oderisi of Gubbio; and in Canto XII he describes an elaborate figured pavement. All three cantos are of special interest to Vasari.

In well-known passages of his lives of Giotto and Cimabue, Vasari refers to Dante's remark in Canto XI of *Purgatorio* about these artists. Here the reference to Dante is explicit, and Vasari builds upon it by developing the legend linking Dante and Giotto, who were said to be friends. The modern reader fails to see that Vasari more subtly invokes the related, subsequent canto of *Purgatorio* in the life of Duccio. He pretends that Duccio, a contemporary of Giotto and Dante, was the inventor of the marble pavement designs in the cathedral of Siena. This work, which is one of the "marvels" of the cathe-

dral, as Vasari says, was not in fact begun until nearly half a century after Duccio's death and was continued by other artists over a period of two centuries. Vasari chooses to link the inception of this great work with Dante's contemporary Duccio because he wants to associate it with the similarly figured "pavimento" in Canto XII of *Purgatorio*.

Vasari implicitly suggests that this glorious cycle of pavement designs is Dantesque—a comparison that encourages us to see Dante's "hard pavement" in terms of the "chiaro scuro" pavement of the cathedral—as if the Sienese pavement helped make visible Dante's speech. In other words, Vasari is saying that in its marvelous beauty, not in the particulars of its subjects, the cathedral pavement indicates how Dante's speech might appear if we could really see it. By connecting the two great figured pavements, Vasari magnifies both, since each work takes on the glory of the other. The key to this comparison is, above all, the glory of Dante's fantasy and, in Vasari's account of Duccio's work, the "real" pavement of the Sienese cathedral is englobed in the imaginative universe of the poet—as if it belonged to the *Comedy*, as, thanks to Vasari, it now in a sense did.

Vasari not only places real works of art in a Dantesque framework, he also invents imaginary works of art out of the imagery of the *Comedy*. This is the case in the life of Parri Spinelli. A delightful, highly idiosyncratic painter (about whom we will have more to say later), Parri is not widely known, for he is not a great master of the stature of his contemporaries Masaccio and Piero della Francesca. He is important to Vasari, however, because he is from Vasari's native Arezzo, and it is important to tell the story of Aretine art, because this art and the artists who made it are part of Vasari's life and experience—of his own autobiography. According to Vasari, poor Parri was wounded by the "evil tongues" of those who were envious of him. In response to this persecution, Parri painted in a chapel a story of "tongues that burn." He depicted some devils around these enflamed tongues and above them Christ, who cursed them with these words: "A la lingua dolosa"—"to the false tongue." We look for this unnamed chapel and the "lost" frescoes in it, but we search in vain, for Parri's allegorical fresco never existed except in Vasari's poetical fantasy.

The key word in Vasari's description of Parri's imaginary fresco is "dolosa," which comes from the Latin word "dolus" for fraud. Even before we read Vasari's phrase, the burning tongues bring us back in imagination to *Inferno* XXVII, in which Dante describes such burning

tongues in the famous description of Ulysses. What is his sin as false counselor but that of Parri's evil detractors—fraudulence. Vasari embellishes Dante by making Parri's adversaries guilty of both envy and fraudulence. In this Dantesque fiction, Vasari imagines the contemporaries of the artist appropriately punished for their sinfulness. These sinners are like those whom Dante condemns in his poem or like Biagio da Cesena, condemned by Michelangelo for his slanderous remarks about Michelangelo's *Last Judgment*—painted in it as Dante's Minos, according to a related fiction. The image of the judging Christ in Parri's imaginary Dantesque fresco makes it into a type of Last Judgment, like Michelangelo's own Dantesque fresco. Vasari's fiction is a pointed parody of Michelangelo's great work.

Inspired by Dante's poetry, Vasari creates his own poetical fantasy. His description of Parri Spinelli's allegory is a word-picture comparable to Dante's imaginings of the reliefs and pavement designs in *Purgatorio*. Its meaning, like that of the works imagined by Dante, is both exemplary and admonitory: a warning to those who are vicious in their envy, who should not condemn others with their fraudulent criticism, for which they will be punished. Vasari's fantasy of Parri's painting is also highly personal, for it not only refers imaginatively to the *Last Judgment* of his friend and hero Michelangelo, falsely criticized by his detractors, but it is also born of the emotions Vasari himself experienced when he was ridiculed by his contemporaries— above all, by the nasty Iacone. Vasari's Aretine ancestor in art, Parri Spinelli, speaks for Vasari Aretino, and for Michelangelo (who was born near Arezzo) when he paints a Dantesque allegory in condemnation of false and vicious criticism. Like Michelangelo, Vasari takes Dante personally. Like Michelangelo, Vasari creates his own poetry out of Dante's.

The ABCs of Giotto's O

When Vasari renders Dante in prose, he follows the example of Boccaccio, who used some of Dante's characters in the tales of his *Decameron*. Like Boccaccio, Vasari is a "novelliere" or teller of stories. Whereas Dante's poem moves toward resolution in *Paradiso*, the

paradise that Boccaccio celebrates is, as it has been called, an "earthly paradise," where, to the reader's delight, all of mankind's pleasures and attendant follies and vices are explored and gently mocked or ridiculed. Boccaccio tells his own stories about artists. Like Dante, he writes about Giotto, and he also tells a number of stories about Giotto's contemporaries, the painters Buffalmacco, Bruno, and Calandrino, which, in turn, inspired further tales about these artists by Franco Sacchetti. In his own sequence of "novelle" about artists included in his lives, Vasari wrote in this novelistic tradition.

One of Vasari's greatest tales concerns the "tondo" or O that Giotto made for the pope's courtier. As Vasari tells it, Giotto drew a perfect circle in a single stroke without using a compass. Brandished with virtuosity, speed, and ease, the "tondo" demonstrated his skill and thus impressed the pope, who called him to work in Rome. The pope's courtier, however, was befuddled by Giotto's drawing of the O because to him it seemed to be nothing. Vasari plays on the ambiguity of the term "tondo," since the word suggests both a person slow or dim of wit, and is also, antithetically, a symbol of perfection. The pope's emissary in Vasari's tale takes the O at face value, seeing it as a nullity, and, in his mental tardiness, what Vasari calls "tardità," he fails to appreciate the meaning of Giotto's rapidly executed, perfect form.

Vasari's story of Giotto's O is so well known that we take it for granted—that is, we take for granted Vasari's ingenuity in inventing it. Vasari invented this story, it has been shown, from a line of fifteenth-century Florentine poetry made proverbial by Poliziano in his *Bel Libretto:* "Al tuo goffo ghiotton darò del macco, / Che più dell'O di Giotto mi par tondo"—"I will give a bowl of mush to your clumsy big glutton who is rounder than the O of Giotto." The wit in Vasari's story depends in part on his ingenious fiction that seemingly gives original meaning to Giotto's "tondo." He also relies for his own tale, it is said, on Pliny's *Natural History,* which tells of Apelles' subtlety in drawing a straight line. Like Apelles, Giotto demonstrates artistic virtuosity, but, whereas Apelles' line was straight, Giotto's is now round. How did the straight line become a circle? Vasari may well have recalled Filarete's garbled allusion to Pliny's story, since when Filarete refers to it, he says that Apelles' drawing was not a straight line but a circle. No matter that Vasari thought that Filarete's treatise was foolish and ridiculous. It was not so foolish and ridiculous

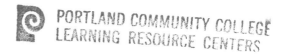
PORTLAND COMMUNITY COLLEGE
LEARNING RESOURCE CENTERS

that he could not perhaps lift the classical prototype of Giotto's "tondo" from it.

Part of the delightful ambiguity of Giotto's "tondo" in Vasari's story resides in its status as geometrical form, as circle, and its meaning as a letter in the alphabet. As the double O of his name (which the poet had played off against the *o* of "goffo," "ghiotton," "darò," and "macco"), the "tondo" is very nearly a compressed form of Giotto's signature. Could it be that, in Vasari's tale, Giotto's "tondo" is not only a sign of Giotto's artistic virtuosity but, as image and letter, is also intended as a kind of condensed emblem? The "tondo"'s status as a letter in the alphabet has its context in Boccaccio's tale of Giotto and Forese da Rabatta, the famous jurist. When both were caught in a rainstorm, they were so disheveled that Forese quipped to Giotto that he scarcely looked like the finest painter in the world—to which Giotto replied that Forese hardly looked like a man who knew his ABCs. The subsequent resounding play on the letter O in Giotto's name would take its place within the context of Giotto's play on letters, that is, the very alphabet Giotto employed to demonstrate his own wit.

Giotto's O also takes its place in the alphabet as Dante described it. When Vasari told his story of Giotto's O, he probably had in mind Dante's vivid description of the burning thieves in *Inferno* XXIV: "Nè *o* sì tosto mai nè *i* si scrisse, com'el s'accese ed arse"—"never was *I* or *O* written so fast as he took fire." In Dante the writing of an *I* or an *O* is a metaphor for velocity, and it is such velocity that Giotto exhibits in drawing his O.

Vasari plays again with the O of Giotto's name in the life of Andrea Pisano. He says that in the time of the "Gotti" and "Greci goffi" (the Goths and Byzantines) Pisano learned from the new drawing of Giotto—playing alliteratively on the O of "Gotti," "goffi," and Giotto. The juxtaposition of "goffo," which means clumsy, and "Giotto" recalls the one in the original poetical line about the "goffo ghiotton," the simple glutton who is rounder than Giotto's O. This is not merely another alliteration, for the like-sounding words "Giotto" and "goffo" are antithetical in meaning. Whereas Giotto's name is synonymous with "virtù," "goffo" stands for the lack of such artistic dexterity or judgment. When Vasari uses "goffo" here in opposition to Giotto, he employs one of the most interesting and charged terms or "vocaboli" in his entire book. Herein lies another story.

Goffism

It is a curious fact that as one of the central words in Vasari's vocabulary "goffo" has not been explored by students of the language of Renaissance art. Vasari uses the word especially to describe a certain clumsiness or awkwardness of art still found in late Gothic or Byzantine works, but he also uses the term to characterize deficient works throughout the Renaissance down to his own day. Speaking of "goffezza" or "gofferia"—the lack of good style—he thus characterizes the lack of "bella maniera." Those artists who have not purged "grossezza" or grossness from their art were "goffi." The term "goffo" comes from the French word "goffe," which wonderfully ascends to our own word "goofy." Vasari is speaking about what we might call goofy art.

In Vasari's general historical scheme, art gradually develops away from "goffezza" toward "bella maniera." The extreme of "bella maniera"—the work of Vasari and his contemporaries—is now called Mannerism by professional art historians. By analogy, we might speak of extreme "goffezza" as Goffism. Some cultural historians have spoken of Mannerism as a recurring phenomenon in the history of culture, when the emphasis on manner or style reaches an extreme of artifice. So, too, we can speak of Goffism as a recurring tendency throughout the history of art. In the very period of Mannerism, or what is also called the Maniera, a school of artists now little discussed but considered by Vasari in his life of Michelangelo, brought Goffism to the pitch of perfection. Goffism can be employed to describe the hideous works by Michelangelo's somewhat simple imitators, Ascanio Condivi, Antonio Mini, Menighella, and Topolino, who transformed the "maniera" of Michelangelo into the Michelangeloid. Disproportionate, crude, and gross, inflated, naive, and bombastic, these works are now, not surprisingly, mostly lost. Their deformities, daubs, or "imbratti," as Vasari calls them, are the pinnacle of "la brutta goffezza"—the very antithesis of "la bella maniera."

In such sixteenth-century Goffism, Michelangelo's nudes are revised into elephantine monstrosities, in which muscles are swollen, as in so many overly inflated balloons; the goofy Goliath of Giulio Mazzoni's *David and Goliath* in the Palazzo Spada in Rome is the supreme type of such Goffism. In sculpture, Baccio Bandinelli's *Hercules and Cacus* is the epitome of Goffism. Vasari's colleague at the

court of Duke Cosimo de' Medici, Benvenuto Cellini, gives us the very vocabulary to describe the "goffezza" of Bandinelli's caricature of Michelangelo. Lacking in grace, being utterly of "mala grazia," Hercules has a head like a "zucca" or pumpkin. His face is not that of a man, but in its fierceness is leonine, just as in its stupidity it is bovine: in a word, "lionbue." His shoulders look like saddles and his muscles resemble those of no man; rather, they look like a "sack full of melons"—"pieno di poponi." Bandinelli's *Hercules* is the very masterpiece of High Goffism.

Future art historians will define more exactly the stylistic nuances of Goffism, using Vasari's "vocaboli" as they contribute to our understanding of one of the most overlooked and forgettable styles in the history of art. In Vasari's words, it is an art to be laughed at—"da burla"—even though its intention is not to be funny. Lacking in "disegno corretto e regolato," correct, well-regulated drawing, it is an art, like that of Tintoretto's *Last Judgment*, which, Vasari says, expresses "confusion." In a word, it is a "garbuglio"—that is, an art in which the best has been removed, as if filtered out by a sieve. Antithetical to "maniera garbata" or graceful style, Goffism is goofy and garbled. It is, Vasari insists, a form of the burlesque and, not surprisingly, as we will see presently, such Goffism becomes the subject of some of Vasari's finest jests.

Words in Pictures

In order to write the history of Goffism, we must turn to a crucial moment in its development, discussed in some detail by Vasari in the life of Buffalmacco. To the pranks and jests of this companionable painter, first recounted by Boccaccio and Sacchetti, Vasari adds a few of his own. Vasari's story of the work of Buffalmacco's friend Bruno at the church of Saint Ursula in Pisa is such a tale; it represents a key moment in the history of Goffism, and for this reason it is worthy of our attention.

Like Buffalmacco, Bruno was a jokester, a member of the "brigata" of artists first vividly described by Boccaccio. According to Vasari, Bruno painted a figure crowned with gold, who personified Pisa, asking Saint Ursula for aid. Because Bruno lacked Buffalmacco's abil-

ity to make his figures lifelike or "vive," he asked Buonamico for help. The latter instructed Bruno to paint words that issued from the mouth of "Pisa" and then to articulate the response of the saint also in the form of painted words. This method pleased Bruno and other fools, "uomini sciocchi," just as, he pointedly adds, it still pleases, in Vasari's own day, "certain clods," "certi goffi," who are plebeian artists, "artefici plebei." Vasari is inventing here a story of how a despised practice came into use; his example accords with his explanations elsewhere of the origins or "principi" of various other artistic procedures. He insists that Buffalmacco invented it as a joke, "per burla," and for no other reason. In Vasari's tale Buffalmacco is again a Boccaccesque prankster. Just as Calandrino and others are his dupes in the stories of Boccaccio and Sacchetti, now it is Bruno who plays his fool.

It has been observed that when Bruno first added words to painted images he invented the modern "fumetto" or comic strip—making such ridiculous or laughable images. It is deliciously appropriate that one of the stars of the modern medium is "un certo goffo" named Goofy, who belongs to the "Nachleben" of Goffism or "Goffismus," as it might have been called by those German scholars who first defined "Manierismus," had they recognized this antithetical historical category.

Bruno's ridiculous invention has a more serious afterlife in the criticism of art. In his classic treatise *Laöcoon: An Essay upon the Limits of Painting and Poetry*, Lessing rebukes painters who use hieroglyphs, purely symbolic signs or images that have verbal meaning: for example, painters who introduce clouds as symbols derived from the poetry of invisibility, as if to suggest "this figure behind the cloud is invisible." The verbal meaning of such an image, Lessing says, is like painted words. He echoes Vasari by adding that this practice is "no better than the rolls of paper with sentences upon them, which issue from the mouths of personages in the old Gothic pictures." This is the ridiculous practice which Vasari pretends that Buffalmacco invented as a prank.

Such criticism *à la* Lessing endures in the modern literature. Speaking of a figure in the frescoes of the Spanish Chapel of Santa Maria Novella, Berenson says mockingly that "if you want to know what edification she can bring, you must read her scroll." Lacking what Berenson speaks of as "Form," pictorial form, this painting therefore lacks "significance." It is mere "illustration." Painted by a near contem-

porary of Bruno and Buffalmacco, the figure mocked by Berenson depends on the addition of words to reveal her meaning and is, as Vasari would have said, "goffa." A great painter, Berenson insists, has "no need to label" his figures, no need for the addition of words. An artist who creates life-enhancing art, such as Giotto, makes his figures adequately "vive," as Vasari might have said; they convey their "significance," Berenson is saying, in their "form." This was already Vasari's meaning, and Lessing, and Berenson after him echo his criticism of the "goffezza" that ensues when words are added to pictures.

What is important to see here is not simply that Lessing and Berenson echo Vasari, which is in itself interesting, but that the origins of their criticism can be traced back to a "burla" or joke. Vasari's Boccaccesque tale about a Boccaccesque character of legendary proportions is playful but also very serious. Like Lessing and Berenson, Vasari is condemning pictorial art that tries to become literature, to be verbal. He is talking about "giudizio" or the lack of such judgment in Bruno, who is the dupe of Buffalmacco when he foolishly paints words. Vasari's story is typical of all his jests—that is, just as Boccaccio's tales make commentary on moral judgment or the lack of it, Vasari's inevitably make serious points about artistic judgment.

Frozen Words

In Book II of Castiglione's *Book of the Courtier,* there is a story about words, which is not unrelated to Vasari's "burla" about Buffalmacco's suggestion to Bruno that he paint words. According to Castiglione's tale, told in his book by Giuliano de' Medici, a merchant from Lucca traveled to Muscovy to buy sables. Reaching the River Dnieper, he saw the Muscovites on the other shore, but he did not cross the frozen river since the Muscovites were there engaged in a war with the Poles. The merchant and the Muscovites began to negotiate by sending signals, and the latter shouted out the price they wanted for their goods. These words did not reach the other side of the river, however, because they froze in the air and hung there in their gelid state. The Poles then built a fire on the frozen river which melted the words and they finally reached the merchant, who, hearing the price being asked, did not accept the offer and returned home without the goods.

Rooted in Plutarch, Castiglione's story was also of interest to Rabelais, who would later refashion it (Book IV, 56). Whatever else it means, this tale evokes in the reader's mind an image of words frozen as such above speaking figures. Although the story does not "picture" these words, how else is the reader to imagine them except as words congealed in space above their speakers—like the painted words above Bruno's figures. I submit that this delightful tale could have been inspired in part by its inventor's experience of figures speaking the painted words in pictures, where the words are seen to be frozen above those who speak them. This medieval convention might have been a seed of Castiglione's "burla," just as it was the basis for Vasari's jest on Buffalmacco's comic advice to Bruno that he depict the very words his figures are speaking. Castiglione's story and Vasari's tale are similar in that both depend on the comic effect of pictured words, on the absurdity of making a metaphor literal. Imagining the ridiculousness of the frozen and painted letters of words, we recall the play on such letters in Dante, who invokes the image of rapidly drawn letters, and in Vasari, who plays with Giotto's "tondo" envisioning the principal letter of his name.

Mock Devils

Although Boccaccio wrote about Buffalmacco, Bruno, and Calandrino, his tales were not ostensibly about art. Sacchetti's stories about Buffalmacco were, however, about Buffalmacco's art, about his "nuove cose" or inventions, and these Vasari collected in his biography of the artist. Repeating these stories, he not only created a cohesive portrait of the artist, but he established a typology of jokes that he would retell in the lives of other artists. Vasari uses such tales later, as we have noted, to explain the origins of artistic practice. His tale of Buffalmacco and Tafi, for example, explains why artists for a time stopped rising at night to do their work.

Retelling Sacchetti's story, Vasari relates that Buffalmacco was a disciple of Andrea Tafi, who rose at night to continue his work. Fond of his sleep, Buffalmacco devised a scheme for escaping this tedious schedule. He attached candles to beetles and released them at the very hour when Tafi came to work. Seeing these creatures, Tafi

thought they were devils and was so frightened that, trembling, he said his prayers and covered his head in his clothes. After Tafi had stopped painting, Buffalmacco brought along a local priest and also told Tafi that these devils were both the adversaries of God and of the artists who portrayed them as ugly. These devils, he added, were also infuriated by painters, because they spent their time making images of saints, who were their enemies. Tafi then followed Buffalmacco's advice not to rise at night, when these demons appeared. After several months, however, prompted by the desire to increase his earnings, Tafi arose once again in the middle of the night, only to be greeted by the terrifying beetles. At this, Tafi decided once and for all to take the advice that had been given to him and not to get up at night to paint.

Sacchetti's and Vasari's story makes many points. In contrast to the industrious Tafi, Buffalmacco is lazy. He stands as the antitype of all those artists admired by Vasari who worked day and night, including Michelangelo. His laziness is not, however, without artistic wit. Indeed, his diabolical, illuminated beetles are artistic inventions, "nuove cose." They are walking sculptures or automata of sorts. When Leonardo da Vinci later took a lizard in the Vatican and covered it, as Vasari said, with wings and scales from other lizards, with eyes, horns, and a beard, before showing it to others to frighten them, he created a bizarre creature like the demons of Buffalmacco's invention that terrified Tafi. Can we be sure that Leonardo made such a creature? Could it just be that Vasari's story is a variation on or embellishment of Sacchetti's "novella" about Buffalmacco? If so, Vasari's tale would also have been wed to Leonardo's theory of the grotesque, reflected in his notion of "animali composti" or fantastic animals made up from parts of different creatures. Just as Buffalmacco's beetles were "giuochi" or jokes, so was Leonardo's lizard, real or imagined by Vasari.

Vasari surely rewrote Sacchetti's story of Buffalmacco's devils in his biography of Spinello Aretino, in which Sacchetti's details are, to use Vasari's vocabulary, "variati variatamente." Vasari says that Spinello painted a figure of Lucifer as a horrifying beast, which later appeared to him in a dream in revenge for Spinello's having depicted him as so ugly. Spinello was so terrified by his dream that he died a short time later. We recognize in his nightmare Buffalmacco's devils, who are the enemies of painters for having depicted them as ugly; only now, in Vasari's variation on Sacchetti, the devil terrifies its own creator. So

real is Spinello's image, achieved through his bold fantasy or imagination, that it seems alive. Spinello's Lucifer is also a variation on the myth of Pygmalion, since the artist's creation, in a sense, comes to life.

Pleasurable Deceits

The stories we have been discussing here have to do with the artist's capacity to create terror, which is a supreme virtue ultimately associated with Michelangelo's "terribilità." In Sacchetti's and Vasari's stories, the capacity to induce fear is treated playfully as farce, but these "giuochi" nonetheless allude to true terror. In a variation on this theme, Vasari invents the tale of Botticelli subjected to the racket from the eight looms of his neighbor the cloth-weaver. The noise of the treadle was deafening, and the movement of the frames shook his whole house. He besought his neighbor to put an end to this racket, but without success. Botticelli finally placed a gigantic stone on the top of his wall, which would fall if shaken, shattering the roof, ceiling, and looms of his neighbor. Terrified by Botticelli's "invention" (if we may call it that), the neighbor came to Botticelli, who told him, in the words he had already used to Botticelli, that in his own house he could do whatever he wanted. Botticelli's ironic threat brought the matter to a close, since the weaver was forced to reach an agreement with the painter.

In this story of mock-"terribilità," Botticelli is like Sacchetti's Buffalmacco—but not just the Buffalmacco who created terrifying devils that frightened Tafi. The story about Botticelli and the cloth-weaver is a free variation on the tale by Sacchetti also retold by Vasari about Buffalmacco and the wool-worker Capo d'oca. Every night Capo d'oca's wife would spin on her wheel, which was near the bed of Buffalmacco, who could not sleep because of the noise. He solved the problem by pouring salt through a hole in the wall separating their dwellings into the pot of Capo d'oca's wife. Capo d'oca then complained to her that his food was too salty, and he set about thrashing her. Buffalmacco convinced Capo d'oca that his wife's cooking had failed because she was working during the night. Capo d'oca then

ordered her not to rise any longer during the night, and thereafter his food was properly salted.

As in the tale of Tafi, Buffalmacco uses his wit to get his sleep when he dupes Capo d'oca. The annoying looms of Botticelli's tale are created out of the spinning wheel in the story of Capo d'oca's wife. In both stories, Botticelli and Buffalmacco use their "ingegno" to overcome "difficultà." This is of course what an artist does in making a work of art, as Vasari says so often. In other words, these comic tales can be read as extended metaphors that stand for the skill of artists. In the stories of Buffalmacco, Capo d'oca and Tafi, the artist-trickster employs "inganni" or deceits to get his way, which are pleasing to us. We are reminded here that Vasari speaks of works of art as "piacevoli inganni" or pleasing deceits. Vasari's tales are also of interest to us when we consider the butts of jokes in them. These gulls range from the artist's teacher and artisans in the examples thus far cited up through the hierarchy of society to monarchs and prelates. The last category brings us to another delightful tale about Buffalmacco.

Buffalmacco's Ape

One of the most famous of Sacchetti's tales about Buffalmacco retold by Vasari concerns the pet ape of the Bishop of Arezzo. When the bishop commissioned Buffalmacco to do a painting in the Vescovado, the ape entered the chapel, picked up the brushes, climbed the scaffolding, and painted a mess of confused figures—in short, "ogni cosa sotto sopra"—that is, everything upside down. At first Buffalmacco expected that this confusion was created by an Aretine artist who was envious of his works, but then he learned that "the new master" was the bishop's ape. With this news Buffalmacco laughed until tears came into his eyes. The ape was finally put in a cage, but even then he continued to make "jokes" with his face and hands.

Sacchetti's story of the ape is a play on the convention of the artist as the "ape of nature." Vasari tells us, for example, that Buffalmacco's contemporary Stefano was called the "scimmia della natura." The story also plays on the conventional theme of the world upside down—everything that the ape paints being, as Vasari says of Buffalmacco's imitator, "sotto sopra." Although the ape belongs to the bishop, he

becomes an extension of the painter by aping him. Buffalmacco's ape reminds us of all the monkeys used satirically in medieval and Renaissance art as vehicles of play and ridicule. The mockery of the bishop's plans has a carnivalesque spirit to it, evoking the parody of the clergy in carnival festivities.

In terms of Vasari's book, the ape of Buffalmacco is more specifically the ancestor of an ape who emerges later as a highly significant figure in the life of Rosso Fiorentino. This tale concerns the ape to whom Rosso became very attached when he was living in the Borgo de' Tintori. The creature took a fancy to Rosso's protégé Battistino, who employed the animal to collect grapes from the pergola of the adjacent gardens of Santa Croce. When the guardian of the garden caught the ape in action, he attacked the ape with a pole, but the animal shook the pergola and fell upon the friar, who cried out for mercy before the ape was retrieved by Battistino. The friar then made a complaint against the ape, which was forced to wear a weight or "peso" attached to a chain. The ape nonetheless devised a clever way of swinging the heavy chain so that he could jump from house to house until he reached the friar's. At this moment the friar was chanting vespers. The ape then did a dance upon the roof of the friar's house, which broke all the tiles on the roof, resulting in the cleric's lamentation. Thus, the ape had its revenge against its accuser. Or so the story goes.

It is remarkable that at this late date Rosso's ape should be taken at face value, as if it really existed, or, that if it really existed, it did what Vasari pretends it did. In this Boccaccesque or Sacchettian tale, the ape is an extension of the artist, clever in its theft and vengeful in its attack on its enemy. Like the bishop's ape in the tale of Buffalmacco, it makes a mockery of the clergy. Ingenious in the very manner in which it overcomes the "difficultà" of its fetters, the ape has the wit worthy of an artist. By terrorizing the friar, the ape is also like Botticelli, who similarly created terror in his irritating neighbor by threatening to bring down his home. Rosso's ape goes a step further than Botticelli, however, since in its wild dance, it in fact breaks the tiles of its adversary's roof.

Rosso's fictitious ape has a significance even deeper than we might have at first supposed. When Vasari says that it wore a weight, "peso," attached to its "ass" ("culo") by a chain ("rullo"), he plays on the rhyme "culo" and "rullo." Vasari is not merely playing with words; he is

referring to the moment a short time later when Rosso was impris-
oned during the Sack of Rome and was likewise locked up, tied down,
like the ape, with weights ("pesi"). The imprisonment of the ape is
thus a foretelling of the incarceration of Rosso himself. The tale of the
ape's imprisonment, related to that of Buffalmacco's creature, is there-
fore extended into a commentary on Rosso's own life. The ape as
symbol of the world upside down appropriately points ahead to the
moment when the world was turned upside down by the invasion of
imperial forces during the Sack of Rome. Like Buffalmacco's ape,
Rosso's creature stands for the painter himself—only now the mock-
ing, playful animal, in light of the painter's subsequent suffering,
takes on a certain pathetic resonance.

Crowns of Fish

Sacchetti's Buffalmacco appears in still another tale that Vasari retells.
The citizens of Perugia, according to this "novella," commissioned
Buffalmacco to paint their protector, the bishop saint, San Ercolano,
in "piazza," but when the Perugians grew impatient because he had
not finished the work quickly enough, Buffalmacco was angered and
sought to vindicate himself. He did this by painting a garland or
crown of fish around the head of the saint. Then, settling his account
with his innkeeper, he set off for Florence. The moral of the story—a
familiar one in the pages of Vasari—is that the patron should be
properly patient in allowing the artist adequate time to complete his
work. This theme would take on epic proportions later in the life of
Michelangelo, with Julius II impatiently awaiting the completion of
the Sistine ceiling decorations, when artist and patron would clash
mightily.

Buffalmacco's "crown of fish" was clearly redefined later by Michel-
angelo in a quip retold by Vasari. There was, Michelangelo suppos-
edly said, a prince who fancied he knew something about architec-
ture. He designed certain niches with rings at the top, in which to
place figures. When he tried to place various statues in these niches
and this did not turn out well, Michelangelo suggested that he hang
eels from the rings. Michelangelo was playing on the alliteration of
"anguille" (eels) and "anello" (ring), while mocking the prince's preten-

sions and lack of artistic judgment. The rings of eels for the monarch's statues in niches were thus a variation on the crown of fish invented by Buffalmacco for the San Ercolano.

It is quite probable that Vasari's quotation of Michelangelo accurately reports a jest of Michelangelo's own—though we cannot quite rule out the possibility that it is Vasari's own "burla." In either case the wit of Michelangelo's reported quip about rings of eels for the monarch's statues depends at least in part on its allusion to Sacchetti's story.

Rosy Cheeks and Bad Breath

Sacchetti is not Vasari's only source of stories about Buffalmacco. Two interrelated tales about the painter appear in the anonymous sixteenth-century *Libro di Antonio Billi*. Both stories, concerning fresco decorations for the nuns of Faenza, are about the origins of certain features in Florentine art and have to do with what painters eat or drink. In the first of these, Buffalmacco, along with Bruno and Calandrino, paints figures without color, and when asked why, the painters reply that they need some good wine. They are then given some Vernaccia, and the color returns to the faces of their figures. Vasari retells this story, saying that the abbess of the church who kept a bottle of Vernaccia to herself criticized Buffalmacco's figures for their deathly pallor—to which the painter replied that the only remedy was some Vernaccia and with this his figures would take on color again. Nearly Rabelaisian in spirit, this anecdote, in both versions, suggests the origins of flesh tones or "carne" in fourteenth-century painting. Wine, as in real life, brings a flush to the flesh.

From the related tale in the *Libro di Antonio Billi* we learn that the nuns used to give the painters garlic and onions to eat. When the nuns asked the painters why they painted their figures from behind, they replied, "what do you expect, you give us so many garlics and onions to eat, and our breath is so bad that our figures turn their backs to avoid the smell." At this the nuns changed the painters' diet, and once again their figures appeared facing forward. The story is about the lifelike character of painted figures so alive that they respond to their painters (shades of Pygmalion?), but it is again a comment on artistic innovation.

For all its playfulness, it comments on the painter's ability to overcome difficulty by rotating form, foreshortening it, giving it relief, and projecting it into depth. Such figures seen from behind, resulting from "rilievo," were seen increasingly in the Trecento, and the anonymous fiction comically comments on this convention. It implicitly explains why it was that figures first appeared in paintings with their backs to the viewer. Vasari does not retell this particular story in his life of Buffalmacco, but he writes variations on it throughout the *Lives*, and it is to these that we will now turn.

Nothing but Cheese

On three occasions Vasari spins out variations on the tale of Buffalmacco poorly fed by the nuns. In the first of these Paolo Uccello flees from San Miniato, where he was painting, because the friars gave him only cheese to eat and he could not stand it anymore. Whenever he met friars of the order of San Miniato, he would run away from them. When two of these friars finally caught up with him, asking why he did not return to San Miniato to finish the job, he replied that the abbot there had fed him so many pies and soups made of cheese that he had become "nothing but cheese" and was terrified of passing in front of a carpenter's shop for fear that he would be made into glue! If he stayed on, he added, he "would probably be no more Paolo but cheese." At this the friars laughed heartily, then told the abbot, who made Uccello return to work and ordered food for him other than cheese.

The second variation on our theme concerns David Ghirlandaio. While at work for the monks of Vallombrosa at Passignano outside Florence, the artist complained to the abbot that he and his brother Domenico were poorly fed, that it was not right to treat them like bricklayers. The abbot promised to do better, but, when David returned to table, he found the same food fit for a hangman. He exploded in a fit of rage, upset the soup on a friar, and, grabbing the bread, fell upon him and so mistreated him that his victim had to be carried to his cell. The abbot, who had already gone to bed, heard this racket and thought the monastery was collapsing. When he discov-

ered the plight of the friar, he rebuked David, but the painter, still enraged, insisted that painters of his brother's rank were worth more than all the abbot-pigs who lived in the monastery. In the end, the abbot, seeing the error of his ways, did his best to treat the painters with the respect they deserved. In this variation on the theme of the painter improperly fed by nuns or friars, the maltreated painter inspires not laughter but terror. Here David is like the Botticelli who terrifies the cloth-weaver. David approaches the ideal of "terribilità" embodied a short time later in the person of his brother's protégé, Michelangelo.

Vasari adds another twist to the tale of the improperly fed artist in his life of Albertinelli. While he was working at the Certosa of Florence, some of his helpers were annoyed that they were not being given the proper food—whence, without Albertinelli's knowledge, they made keys to the windows opening to the rooms of the friars, through which their food was passed. Now they could steal food from them, and this they did. Friars, like all men, care about what they eat, and there was an uproar when they learned that their food was missing. The helpers, without great guilt, led the friars to believe that they were stealing from each other. This was easy to do, since there was enmity among them. Eventually the friars discovered the truth and, in order for the work to be done, a double portion of food was given to Albertinelli and his disciples, who now completed their task with glee. In this case, Albertinelli's helpers are less like the ridiculous Uccello or furious David than like Buffalmacco, resorting to cunning—a guile appropriate to masters of illusion or deception. It is only fitting that their trick should result in laughter.

The Fake Painter

Artists are often tricksters, who employ their guile in real life, as the storytellers tell us, just as in the play or illusion of their art. Nowhere do we see this cunning more marvelously than in the tale of Buffalmacco's manikin. Nowhere do we see Vasari's wit more splendidly than in his invention of the tale of the manikin.

Vasari begins by saying that Buffalmacco was so careless in his dress

that the nuns for whom he worked mistook him for a "garzone" or artist's helper. The abbess then told him that she would prefer to have the artist, not him, at work—to which he replied that he would tell the master. At this Buffalmacco constructed a fake master by placing a water jug on a stool, covering it with a hood and mantle and putting a brush in the spout, as if in a hand. When the nuns saw this fictitious master in pontifical garb, as Vasari says, they thought it was the master at work, not the "garzone." Having grown desirous of seeing the master's work some days later, the nuns came to the spot where the fake artist was placed and discovered that, no work having been done, they had been fooled. Although Vasari does not say so, he implies that the reason they had been fooled in the first place was that they saw the manikin from behind, otherwise they would have seen that the "master" had no face and was a hooded water jug.

What Vasari is doing here with great cunning is nothing less than reworking the earlier fiction from the *Libro di Antonio Billi* of Buffalmacco's figures seen from behind, now transforming them into Buffalmacco himself. But there is more to the story. Vasari makes the point that the nuns attached too much importance to dress. With a big laugh Buffalmacco says to them: "You must judge a man by his works, not by his clothes." This judgment is one of the major themes of Vasari's book.

Michelangelo's Advice on Fashion

Vasari's tale of Buffalmacco's dress is not unrelated to Michelangelo's attitude toward clothing. As Vasari says, Michelangelo was often so absorbed in his work that he forgot about his clothing. He underscores this point by observing that Masaccio, Brunelleschi, and Donatello, all types of Michelangelo, also did not care about their dress. He perhaps recalled but did not retell the story in Vespasiano da Bisticci's memoirs about Donatello, who received fine garments from Cosimo de' Medici, only to reject them because they were not so comfortable as his old garb. What was important to Vasari and Michelangelo both was "virtù," not outer dress.

Vasari tells two stories that likely reflect Michelangelo's own atti-

tude. In one Michelangelo pretends not to recognize a friend, a cleric, all dressed in finery, saying to him ironically: "O you are so handsome. If you are on the inside as you appear on the outside, it will be good for your soul." Michelangelo is commenting on his friend's exaggerated emphasis on clothes, which have nothing to do with virtue or devotion. The remark echoes his more famous remark in response to the pope's desire to ornament figures in the Sistine Chapel in gold. Michelangelo exclaims that this is inappropriate, since these are holy personages who despised wealth. It is for Michelangelo ridiculous to confuse outer dress with inner virtue. He similarly laughs mightily when Menighella, who painted a Saint Francis in gray garb for a peasant, repainted the saint's costume as a pluvial in brocade because the peasant was not satisfied. Menighella is as simple or "goffo" as his patron, since such splendid dress is inappropriate to the ascetic saint.

These tales of Michelangelo's drawing the distinction between dress and spiritual virtue are all related to the tale of Buffalmacco. Although there is a difference between a painter and a cleric or holy person, there is a relation between a painter of holy subjects and a holy person, since art is for Vasari, as for Michelangelo, a spiritual exercise. Artistic "virtù," while not identical with spiritual "virtù," is closely related to it, and often for Vasari they are synonymous. Vasari's tale of Buffalmacco is related to Michelangelo's quips, because in his story it is nuns who are mocked for judging a man by his outer garb, not by his works. These nuns, who should know the difference between virtue and appearances, are thus related to both the pope and the cleric mocked by Michelangelo for their exaggerated attention to outer appearances.

It is in fact not improbable that when Vasari invented his story of Buffalmacco's manikin he had Michelangelo's remarks on clothing and outer appearances in mind. In his humble garb, Michelangelo epitomized the ideal artist of virtue, who was not concerned with earthly matters but with spirituality. Buffalmacco was not such a virtuous artist, to be sure, but the fact that we laugh at his jest of the manikin does not mean that it is not in earnest. Vasari is making the serious point that the nuns, like the devout butts of Michelangelo's jests, cannot see beyond false appearances. We laugh at Buffalmacco's nuns in the same way that Michelangelo laughed at the foolish artist who painted Saint Francis in brocade.

Gherardi's Cloak

When Vasari invented the tale of Buffalmacco in simple attire, he also drew on Boccaccio's story of Giotto, in which Giotto's skill and wit shine through his disheveled attire. The very point of Boccaccio's story about Giotto is put into the mouth of Buffalmacco, who says, "You can't judge a man's works by his clothes." This moral has a long history in Florence. It is implicit in the above-mentioned story of the new cloak, hood, and mantle given by Cosimo de' Medici to Donatello, who rejected them because they were not so comfortable as his old clothes. Usually taken at face value, this story is likely another fiction—an enduring exemplary tale, which insists that an artist's attire has nothing do to with the excellence of his work. Donatello was a great artist, as Vasari would later argue, despite his indifference to fine clothing.

Such stories persisted, and Vasari retold them about his contemporaries, just as he told them about past artists. In the life of his protégé Cristofano Gherardi, Vasari makes the artist into a kind of latter-day Donatello. Indifferent, like Donatello, to money and clothing, Gherardi left his savings not only to his family but to many poor people. In the pages of Vasari's life of Gherardi, the artist emerges as a deeply lovable character on account of his foibles and comic responses to clothing. There may be some truth to these stories, but they are so much like the tales told by Vasari and others about earlier artists as to make us wonder whether they are not in fact fictions.

Vasari tells us in one of these tales that Gherardi would frequently arrive at his work without having finished dressing. At times he would put on shoes that were not of the same pair, and often, too, he wore his cloak with the wrong side out and his hood inside. Duke Cosimo, who had great affection for Gherardi, laughed at the artist, asking him why he wore his cloak inside out—to which Gherardi replied in the fashion of Buffalmacco: "I don't know, my Lord, but I mean to find some day a kind of cloak that shall have neither a right side nor a wrong side, for I have not the patience to wear it in any other way . . . but let your Excellency look at what I paint and not at my manner of dressing." The duke responded to the painter's words by sending him a cloak sewn in such a way that it made no difference whether it was seen from the inside or the outside. To this Gherardi

responded by telling the lackey who delivered the cloak: "Tell him [the duke] that it suits me fine."

Gherardi hated new clothes so much, we read, that Vasari used to put them in Gherardi's room, removing the old ones so that Gherardi was forced to wear the new clothing. Gherardi would object: "What devilments are these?" One day he put on a new pair of white hose, but after a day of walking he tried to take them off before going to sleep and could not remove them because he had sweated so much that they stuck to him. So he fell asleep with his stockings on. Finding him asleep, Vasari, with the help of an assistant, tried to pull them off, the servant holding one leg, while Giorgio pulled at the hose on the other. Meanwhile Gherardi, awakened, cursed these clothes, their inventor, and Vasari himself. He claimed that such clothing kept men bound like slaves in chains. The story is not only delightful in itself, but it suggestively puts us in mind on a grander scale of Michelangelo's self-forgetfully falling asleep without removing his boots. When he finally took them off, they stuck to him, and he peeled away some of his skin getting them off. Forget all the finery, these stories tell us over and over—forget all the cloaks, mantles, hoods, and stockings, all that haberdashery, since an artist is judged by his works, not by his attire. Thus spake Buffalmacco and his progeny.

Haberdashery as Farce

The corollary of Vasari's proposition that artists can dress shabbily and still make excellent works is that artists who overdress are not distinguished because of their sartorial splendor. In fact, Vasari, speaking of Alfonso Ferrarese, condemns such vanity. The artist used to wear around his neck, on his arms, and in his clothing gold ornaments and various fripperies that made him appear more like a vain and wanton courtier than an artist aspiring to glory. If these ornaments were appropriate to the wealth and splendor of those of noble blood and thus of higher station, they were not, Vasari insists, appropriate to artists, who should not compare themselves to men of class and wealth. If they did so, they were to be laughed at—as was the silly, pretentious Alfonso, who fell in love with a lady of station and, re-

jected by her, was ridiculed by all those who heard of his posing and posturing.

Vasari has the same kind of comments to make about the painter Sodoma. He was so interested in his amusements that he worked only by caprice. Again the playful ghost of Buffalmacco. But Sodoma "cared for nothing so earnestly," Vasari says disapprovingly, "as for dressing in a pompous fashion, wearing doublets of brocade, cloaks all adorned with cloth and gold, fancy caps, necklaces, and such fripperies fit for charlatans and fools." Vasari's mockery of Sodoma recalls Michelangelo's jests about pretentious dress. Vasari tells us further that for all Sodoma's pretentions, his patron, Agostino Chigi, nonetheless liked the man's humor and found him to be very amusing. If Chigi laughed at Sodoma, so does Vasari, and so do we his readers.

Bernard Berenson once remarked that Vasari is a writer with great sympathy for his subjects. Even when he condemns Alfonso and Sodoma for their vainglory, he makes them appealing in their folly, and we enjoy their pretensions. For his capacity to write so vividly about figures who personify vice, making them attractive to us notwithstanding his condemnation of their vices, Vasari is indebted to Dante, who similarly inspires our sympathy for many of the sinners whom he has condemned to hell for their vicious ways. Is there a greater example of this ambiguity than Vasari's Buffalmacco, who is profoundly lovable despite the fact that he is lazy and personifies sloth?

Novella into Biography

We have by no means exhausted all the tales of Buffalmacco received or invented by Vasari and brought together into his biography of the artist. Vasari also retells Sacchetti's tale of Buffalmacco painting the lion of Florence triumphant over the eagle of Arezzo for the Bishop of Arezzo, who requested that he paint the very opposite of what he painted—that is, Arezzo victorious over Florence. Vasari invents the story of Buffalmacco, who depicts Saint Christopher lying down because the silly patron commissioning the work asked him to paint a figure twelve *braccia* high in a space of nine *braccia*. In a related tale, also of Vasari's invention, Buffalmacco, indignant when a patron re-

fuses to pay him, repaints a Christ Child as a bear and, when he is finally paid, he sponges this overpainting off. In other tales, Vasari tells us, too, that the Buffalmaccesque painter Nunziata, "burevole e faceto," paints a beard on a Madonna after he is accused of making her lascivious and, when he is asked by a clod or "goffo" for a Crucifix for his summer residence, he paints Christ—with mock decorum—in shorts! Or so Vasari pretends.

All the tales told by Vasari about Buffalmacco add up to a vivid portrait of a playful, lively character. How does Vasari fashion these tales into a life? He combines them with descriptions of various Trecento works that he ascribes to the artist—stressing that the artist made his figures express lively emotions. Rage, sorrow, fear, and terror are some of these "affetti" said to be expressed in the artist's works, and these emotions correspond to the vivid "affetti" or emotions mockingly brought out in the tales about the artist, who is so capable of inspiring strong emotions as a result of his pranks. Vasari fuses the tales of the painter with the catalogue raisonné of works attributed to him in order to make a compelling portrait of the artist. His success depends on a correspondence between the artist's vivid personality in these Boccaccesque stories and the lively naturalism of Trecento painting. When Vasari tells us that Buffalmacco painted naturalistically an old man blowing his nose, he describes a pungent detail worthy of the "novelle" about the artist. The vivacity of Buffalmacco's escapades has its counterpart in the naturalism of his art and that of his contemporaries—Taddeo Gaddi, for example, or Simone Martini.

The materials for Vasari's biography of Buffalmacco already existed in Sacchetti's Boccaccesque tales about the artist, but it remained for Vasari to bring all of them together into a coherent whole, both embellishing them and linking them into a series of episodes in a life corresponding to the artist's work. The life of Buffalmacco is a striking example in the pages of Vasari of how the "novella" is transformed into biography. When Vasari says that Buffalmacco died very poor because he spent everything he had made, this is an appropriate final touch to the biography of the lazy, witty, fun-loving, and funny painter. For all Vasari's own fun in telling Buffalmacco's story, he concludes with a typical moral—that painters should lead well-regulated lives.

The Fable of Castagno

Just as Pygmalion created a statue, which was transformed into flesh, so did Vasari in his literary fictions portray characters who seem real. Buffalmacco is but a single example in the pages of Vasari of a character presented in fictions that create the illusion of a real-life person. Consider another example of a different sort—Vasari's creation of Andrea del Castagno. We know almost nothing about the artist. The artist's biography is but a series of works and a few attending documents. It is highly schematic. Vasari's Castagno is really a make-believe figure who becomes a flesh-and-blood character because Vasari invents him out of fictions based on the character of his works.

Vasari relates the crudity if not violence of his harsh art to the documented murder of an artist named Domenico. Vasari pretends that it was Castagno who murdered Domenico Veneziano. This violent deed becomes the central deed in the life of an artist whose work is notable for its harshness. Raised among beasts, as Vasari tells us, Castagno is bestial in character; he is as cruel and diabolical as his art is harsh. No matter that there was once a painter named Castagno. Vasari's Castagno, like his Buffalmacco, is essentially a fiction.

Castagno is as violent, Vasari pretends, as his own animated art. Thus, he scratches the works of other artists. He is like those simple, pious folk who were inspired to scratch the realistic, evil subjects of his own art. Castagno is, Vasari pretends, a man of rage and, according to one story, he flies into a fury when a youth knocks down his ladder while he is working on the fresco of the warrior Niccolò da Tolentino. Fierce and violent, Castagno is himself a warrior; he is impelled to strike his critics and, finally, to murder Veneziano. No wonder, as Vasari makes believe, Castagno portrays himself as Judas. All of this is fiction, we tell ourselves, yet Castagno continues to "live" in our imagination just as Vasari imagined and described him: as a fiery, violent character. The portrayal of Castagno is so vivid that critics still feel the need, as Milanesi did in the nineteenth century, to spare him the "atrocious imputation" of Vasari's fable. The fact of the matter is that when Vasari created "Castagno," he fashioned a fictitious figure that, like Pygmalion's sculpture, came to life. Pygmalion's creation was beautiful, Vasari's was monstrous, but like Pygmalion's creation, Vasari's was turned into a seemingly real-life being in the flesh. By whom? Both by Vasari and by compliant readers happy to suspend disbelief. Even after we

analyze the fictitious nature of Vasari's "Castagno," we easily slip back into our habit of believing in his "reality."

Zuccone as Idol

The myth of Pygmalion is central to the very iconography of Renaissance art. All art aspires to the condition of Pygmalion's statue, so natural as to seem alive. Vasari tells us that Bronzino painted Pygmalion praying to Venus that the sculpture he had made might, vivified, become flesh and blood and receive the spirit. The painting was made as a cover to the portrait by Pontormo of Francesco Guardi. The generally undiscussed point of this subject is obvious. The cover of the portrait suggests that Guardi appears as a living person in the flesh, like Pygmalion's creation.

Vasari's explicit references to Pygmalion are, however, equivocal. In the "proemio" to the *Lives*, he speaks of Pygmalion approvingly as a mythic sculptor of antiquity whose work was brought to life through the intervention of Venus. In another "proemio" to his work, however, Vasari refers disapprovingly to Pygmalion's "unbridled passion" for the subject of his art. This disapprobation is part of Vasari's larger discussion of the lasciviousness of art. Such equivocation is found elsewhere in Vasari's ambiguous allusions to the myth of Pygmalion.

In a variation on the theme of Pygmalion, Vasari says that Donatello's *Zuccone* was so lifelike that the sculptor expected the statue to speak, and when it did not, the artist, flying into a rage, smashed his own work. In this tale Donatello becomes a modern Pygmalion, or nearly so. But is this all that Donatello becomes? Is he not like one of his own prophets smashing his image, as if it were an idol? The *Zuccone* has traditionally been identified as the prophet Habakkuk, although recently a convincing argument has also been made for the identification of the prophet as Elisha. The large, imposing mantle of Donatello's figure is seen here as the mantle of Elijah that fell on Elisha before he asked, "Where is the Lord God of Elijah?" (2 Kings 2:13–14). Whatever the original identity of Donatello's statue might have been, Vasari could have had Habakkuk in mind, since Donatello's response to his statue evokes, as it has been observed, Habakkuk's condemnation of idols: "Woe unto him that saith to the wood,

Awake; to the dumb stone, Arise, it shall teach! Behold, it is laid over with gold and silver, and there is no breath at all within it." In the "proemio" to the *Lives* Vasari had condemned "idolatry," invoking the example of the ancient Hebrews. Now he seemingly refers to the Hebrew Bible again, suggesting that Donatello is like those who seek the "dumb spirit" in a sculpture, which is but an idol. Donatello is in Vasari's fiction at once an idolatrous modern Pygmalion creating a lifelike statue that he expects to be filled with spirit and, ambiguously, a modern prophet smashing and condemning his own idol.

Pygmalion and Medusa

The comparison of Vasari's characters to Pygmalion's creation is not gratuitous, because Vasari always has Pygmalion in mind, both specifically when he speaks of the mythic sculptor at the beginning and elsewhere when he alludes to him. Vasari writes, for example, a witty variation on the theme of Pygmalion when he tells the story of Iacopo Sansovino's disciple, Pippo, who posed for his statue of Bacchus. Before the statue was even finished Pippo went mad—perhaps from standing too long in one position in the sun. One day when it was raining hard, Sansovino saw Pippo, on the chimney of a roof, posing naked as Bacchus. Pippo did not answer to his master's cries. At other times Pippo would climb to a high place and pose as a prophet or an apostle or a soldier, staying still for hours, as if he were a sculpture. "Poor Pippo," he was never able to forget the *Bacchus*, and he died a few years later. Vasari's tale concerns the lifelike pose of the Bacchus, the difficulties of posing, and, finally, plays on the myth of the sculptor Pygmalion. Inverting the myth, Vasari writes delightfully of a man who becomes a sculpture. If professional art historians have never doubted the story of Pippo, if they have not seen that it is a fiction, a playful refashioning of a myth, this is because they are sometimes, in Michelangelo's memorable words, recalled by Vasari, "solennissimi goffi"—most solemn boobies.

Whereas Pygmalion made a sculpture in ivory that became flesh, Medusa did the reverse, turning into stone those who gazed upon the Gorgon. Vasari is no less fascinated by the myth of Medusa than by that of Pygmalion. The story of Pippo is not about the myth of Medusa

as such, but its description of a man becoming a sculpture, if in imagination, certainly evokes it. Vasari plays with this myth when he describes a painting of the subject by Peruzzi in the villa of Agostino Chigi. He says that Titian was fooled by the painter's illusion and did not want to believe that it was painting he saw, observing that Titian was "maravigliata." Amazed, Titian was thus stupefied and, as Vasari implies, the Venetian painter shared in the experience of those "converted to stone" by the Medusa, since they were similarly stupefied. The play between painted images and flesh, between stone and flesh, is even carried into the discussion of the architecture of Chigi's villa, built by Peruzzi. Vasari says that the building was of such "grace" that it seemed to have been truly born ("veramente nato"), not built ("murato"). Not only does Vasari create a nice rhyme between "murato" and "nato," but he plays on the difference between being born in the flesh and being made out of stone.

Sometimes the myths of Medusa and Pygmalion are linked. Thus, the strange Leonardo, who was capable of inspiring terror in other artists, as Vasari says, made a Medusa as one of his earliest works. It was, Vasari tells us, utterly monstrous and horrible. Did Leonardo in fact make this painting, which may instead be a kind of metaphor of the terrifying powers of the artist? There is in any case something of the Medusa in Leonardo's *Mona Lisa*, or rather in Vasari's description of the painting. Its naturalism is so astonishing, Vasari insists, that it makes every bold artist tremble and fear its creator. Not only does the Medusa thus lie beneath the surface of Leonardo's creation, as Vasari sees it, but so too does Pygmalion. The Mona Lisa is so lifelike that she appears to be of real flesh or "carne," and one beholds the very beating of her pulses. In Vasari's description of Leonardo's famous portrait we already discover the mythic *femme fatale* of the nineteenth century, especially of Walter Pater. Transformed into living, palpitating flesh, the terrifying Mona Lisa is a Medusa-like creature by a modern Pygmalion. Or so Vasari suggests.

Playing on Petrarch

To understand more fully the significance of the myth of Pygmalion for Vasari, we must contemplate Vasari's relations to the third major

Tuscan poet, who, along with Boccaccio and Dante, stands behind his accomplishment: Petrarch. When Vasari says that his work is "rozza" or rough, he uses the very word that Petrarch had employed with similar rhetorical modesty to speak of his own poetry. This is likely the case because Vasari often has Petrarch's language in mind—as, for example, in the story of the vainglorious, overdressed Alfonso Ferrarese, whom we have encountered before. In a scene worthy of the finest Cinquecento "commedie," Vasari plays on Petrarch's *Canzoniere* when he describes the folly of Alfonso in love at a torch-light banquet. Full of love, overwhelmed with passion, his eyes full of tenderness as he gazes at his beloved, Alfonso resorts to the language of love in Petrarch: "S'amore non è, che dunque è"—"If it is not love that I feel, what is it then?" With charming wit the lady deflates our poor lover by replying laconically: "a louse perhaps."

Vasari's playful parody of Petrarch here is in the current of anti-*Petrarchismo*—the teasing with Petrarchan conventions—pervasive in Cinquecento literature, whether we find it in the poetry of Michelangelo or in Shakespeare. Such parody, including Vasari's use of a famous line in Petrarch, depends on the currency and authority of the poet. Of all Petrarch's poems in the *Canzoniere*, the most important to Vasari are those that describe Simone Martini's portrait of the poet's beloved Laura. Vasari quotes from both of these poems in the life of Martini, and he refers to them again in his life of Bellini.

Vasari's point is to stress Martini's good fortune in having his fame established by the poet. By analogy, Vasari plays the Petrarch to all of the painters whose immortality he aspires to establish through the *Lives*. He makes the connection of Martini to Petrarch and to his portrait of Laura by pretending that in one of his frescoes he portrayed Madonna Laura sitting in a garden and dressed in green with a little flame between her breast and throat. Vasari sees Petrarch's Laura pictured by Martini in a fresco, which is an allegory of the ascent of the soul toward paradise. By seeing her in this heavenly image, Vasari is playing on Petrarch's claim that in order to paint her Simone was himself in paradise, that Laura's image could only be conceived there.

When Vasari invokes Petrarch's poems about Laura, he necessarily invokes Pygmalion, because the poet does so in comparing Martini's Laura to Pygmalion's beautiful creation: "Pygmalion, how glad you should be of your statue, since you received a thousand times what I

yearn to have just once!" Martini's portrait of Laura—not inconceivably a fiction—was a metaphor for Petrarch's own creation of Laura. Even if the poet's Laura were related to a person who once lived, the "Laura" who endures is the fiction of the poet. Petrarch, as he himself suggests by alluding to Pygmalion and as Vasari understands, is a Pygmalion, who creates a woman, bringing her to life. By analogy, Vasari is a Pygmalion bringing to life his artists, who are often similarly fictions. Just as Petrarch used Martini's portrait of Laura to refer to his own role in fashioning her, Vasari uses the works of art of his subjects to make them come alive—as is the case, for example, in the lives of the vivacious Buffalmacco and the treacherous Castagno.

Living and Dead Stone

If Petrarch inspired Vasari's reflections on Pygmalion in some measure, he also had more than a little to do with Vasari's musings on the myth of Medusa. Over and over Petrarch plays on the meaning of his own name, which has its root in "petra" or stone, saying that he has been turned into stone by his beloved, who is likened to Medusa. Petrarch followed Dante, who, in his "rime petrose," spoke of himself as petrified by his "donna petra," and later Michelangelo, responding to both Dante and Petrarch, wrote of himself as a sculpture when he became his own *Night* in his poetry. Vasari follows this lapidary line of poetry in his life of Michelangelo.

Vasari quotes in full Giovan Battista Strozzi's poem on Michelangelo's first *Pietà*, which uses such a Petrarchan conceit. Strozzi says that "pain, pity, and death are alive in dead marble"—"in vivo marmo morte." He alludes to Petrarch's *Canzoniere,* where the poet speaks of himself as petrified by his Medusa, himself a dead stone in a living rock: "pietra morta in pietra viva." Vasari is saying through Strozzi's Petrarchan poem, which is like Michelangelo's own poetry, that Michelangelo's figures are alive within stone, as Petrarch is alive in dead stone. He is, however, saying something more. His use of the word "vivo" suggests the life of Michelangelo's figures in stone, but this vitality is more than the imitation of nature. Petrarch's Laura is a figure of Christ through whom the poet is reborn. Such rebirth is also intended by the poem quoted purposefully by Vasari. In the descrip-

tion of a sculpture that represents the death of Christ, the phrase "alive in dead stone" also stands for the rebirth of the soul through the sacrifice—for resurrection.

Raphael and Laura

When Vasari writes the life of Raphael, he again relies on Petrarch. His use of Petrarch here is especially appropriate, since Raphael wrote Petrarchan poetry and, according to Vasari, portrayed Petrarch among the poets atop Parnassus.

In order to understand Vasari's use of Petrarch in the life of Raphael, we must say a few words about the key date in the poet's life—this is April 6. On this date in 1327 Petrarch first beheld Laura; this was therefore the date of his spiritual rebirth. April 6 was also the date that Laura died in 1348. According to fourteenth-century tradition, April 6 was the date of man's birth, of his death, and of Christ's sacrifice. In Petrarch's "rime," Laura is the figure or "figura" of Christ, and Petrarch structures his life, his own spiritual renewal, in relation to his Christ-like beloved. Raphael's friend, Pietro Bembo, who owned a partially autograph manuscript of Petrarch's poetry and who wrote a commentary on the poetry, composed an epitaph when the artist died. Bembo wrote that Raphael was born and died on the same day in 1483 and 1520. What was this date? April 6! Bembo thus gave Petrarchan meaning to Raphael's life by linking the artist's life and death with events in the life of the poet. Vasari recorded Bembo's epitaph, interpreting it in accordance with the tradition linking April 6 with Christ's death, by saying that Raphael died on Good Friday—the day of Christ's sacrifice immediately antecedent to his rebirth.

Vasari exploits Bembo's Petrarchan chronology of Raphael by associating Raphael's own birth and death on April 6 with the death and resurrection of Christ. He pretends that Raphael's last painting was the *Transfiguration of Christ*, saying that the artist painted or "figurò" "Cristo trasfigurato." He thereby links Raphael to Christ through the play between figuration and transfiguration. In fact, he in a poetical sense transfigures Raphael into a type of Christ, just as Petrarch has transfigured Laura into a "figura" of Christ. Painting the transfiguration of Christ, Vasari is suggesting, Raphael thus experienced his own

transfiguration. Vasari is relying on the very poetical tradition of Dante that Petrarch used, since in his *Vita Nuova* Dante had spoken of his own "trasfiguramento" or spiritual transfiguration when he first beheld Beatrice. Petrarch was similarly transfigured when he beheld Laura and now, in Vasari, Raphael, painting the transfigured Christ, is himself transfigured. When Vasari adds that Raphael gave up his last breath after painting Christ's face, he further invokes Saint Paul's words in Corinthians, since the painter now saw Christ "face to face."

As Petrarch's biographical poetry is saturated with references to the Bible, so too is Vasari's poetical biography of Raphael filled with such biblical allusions. Vasari says that Raphael was a "gift" sent from heaven, alluding to the true gift of grace through Christ's sacrifice. He also says that his father Giovanni Santi set his son on the "good path," playing on his father's name, John. He invokes the artist's patron saint, John, who prepared the way for Christ. Vasari similarly comments on Raphael's family name and its meaning at the end of the biography of the painter, speaking of his "costumi santi." Worthy of his name, Vasari's Raphael is a poetically conceived figure—like Petrarch's Laura, a heavenly figure, whose life is directly linked with Christ's.

Vasari's Raphael is like Petrarch's Laura in a deeper sense. Even if there was a real Laura upon whom Petrarch modeled the beloved of his poetry, the Laura who endures is a creation of the poet, the Laura of the *Rime*. Similarly, the Raphael who continues to hold our imaginations is not the real Raphael—whoever that might have been—but the Raphael poetically conceived by Vasari. A shrewd art historian once observed that although Raphael was a supreme talent, he also needed to be pragmatic and tough in order to survive and flourish in the fiercely competitive art world of Rome. Vasari's Raphael is instead gentle, kind, and loving—a fiction like Petrarch's Laura. Like Laura, Raphael becomes a poetic figure, and the poet who created this Raphael out of the very tradition of Petrarchan poetry was Vasari.

The Philosophy of Nomenclature

When we consider Vasari's play on Raphael's family name, Santi, or Petrarch's play on his own name, his speaking of himself as "petra" or

"pietra," we enter into the realm of what Robert Louis Stevenson called the "philosophy of nomenclature." According to this philosophy, which is important to our understanding of Vasari, names are of the greatest significance: they comment on the essences of things. As Dante said and as Vasari understood full well: "Nomina sunt consequentia rerum"—Names are the consequences of things.

In modern literature, the key text in the "philosophy of nomenclature" is *Tristram Shandy,* where Walter Shandy argues that there is a kind of "magic," according to which good and bad names "irresistibly" impress themselves upon the characters of those who bear them. "Who," he asks himself, "might have done exceeding well in the world, had not their characters and spirits been totally depressed and Nicodemused into nothing?" Through the cruelest fate, an accident, his son, who should have been named Trismegistus, "thrice great," came to be named Tristram—"Melancholy dissyllable of sound." The saddest of names, in its Latin essence, this is a name worthy of a "Nincompoop."

Walter Shandy's meditations on nomenclature belong to a long tradition that can be traced back to classical antiquity and to the Bible. The names of the epic heroes of Homer have the deepest significance; for example, Hektor is said to mean "shielder," and Joseph in the Hebrew Bible appropriately means "increaser." Etymology has been called a "category of thought" by E. R. Curtius, who traces the etymology of names from antiquity into the modern period. A principal figure in this history is Isidore of Seville, whose *Etymologiae* is filled with learned but fanciful explanations of the origins of words. The fanciful etymologies of saints' names in Iacobus Voragine's *Golden Legend* are also notable in this regard. In the Renaissance such etymologies are also fanciful, often poetical and highly playful, as in the inventions of emblems and devices. Erasmus played, for example, on Thomas More's name, dedicating his *Praise of Folly* or *Encomium Moriae* to him, just as Sannazaro played on Poliziano's name, derived from his birthplace Montepulciano, which contains the name "pulce" for flea! Poets would often write playfully about their own names. Shakespeare played on his name in his sonnets when he spoke of "will," and John Donne spoke of himself when he wrote of what was "done." Long afterward this tradition remained alive in Wordsworth, who signed a poem in Greek, which emphasized through translation that he was worthy in words.

Fiction abounds in such significant names. Dante's Beatrice is indeed blessed, Jane Austen's Knightley is knightly in his courtliness, Joyce's Gretta in "The Dead" personifies regret. Sometimes such play on names is comical, as in the comic-strip character Dick Tracy; both of his names refer to his profession as a detective or "dick," who traces criminals. Readers can multiply these few examples into a Homeric catalogue of their own from their own experiences of life and literature.

Vasari's commentaries on names are sometimes serious, often comic, but always ingenious and playful. The elucidation of Vasari's play on names will open up for consideration a vein of poetical fantasy scarcely suspected by past readers. It is necessary in approaching this topic to consider that in Vasari's "vocaboli" the word "nome" or name is one of the most important terms. Vasari uses few phrases as often as "acquistare nome"—to acquire a name. He speaks of the good and great names of artists, which assure their "gloria" or "fama." His book is dedicated to perpetuating these names, and he is forever commenting on their glory and significance. A good name is above all to be preserved and protected. Thus, it is Vasari's purpose in his life of Piero della Francesca to protect the artist's name against the efforts of Luca Pacioli to "usurp" Piero's honor by publishing under "his own name" the work of Piero himself. Pacioli does nothing less than seek, Vasari says, "to annul the name of Piero," and Vasari will not allow this to happen.

The importance of an artist's name is the subject of numerous jests. Vasari relates that when Giuliano, son of Francesco di Paolo Giamberti, was commissioned by Lorenzo il Magnifico to build a convent outside the Porta San Gallo, Lorenzo named him Giuliano da San Gallo. Hearing everybody call him "da San Gallo," Giuliano said in jest, "By giving me a new name, 'da San Gallo,' you cause me to lose the ancient name of my house, so that in matters of family lineage rather than going forward I go backward." To this Lorenzo retorted, with characteristic wit, that with this new name Giuliano was now the founder of a new house resulting from his own worth as an artist; with this explanation Giuliano was content. On the surface, Vasari's tale plays on the artist's social ambitions, bringing out the importance of one's name to one's social status. The artist's name, Lorenzo insists (or rather Vasari tells us in his jest), depends on his skill or "virtù."

Vasari made this point explicit when he played on his own name and virtue in his portrait of Lorenzo il Magnifico, now in the Uffizi. To

the right of his subject Vasari painted a vessel upon which were inscribed prominently the words VIRTUTUM OMNIUM VAS. This tag is a celebration of Lorenzo as a vessel of all virtues, but the vase is also a pun on Vasari's own name, which is based on "vasaio" or vase maker, since Vasari descended from vase makers. The image is thus ambiguous, since it refers both to the subject of the painting and the painter. Vasari is here like Brunelleschi and Michelangelo, who, he elsewhere said, spoke in "two senses." By combining word and image, Vasari signs the work with his poetical emblem or "impresa." This is by no means all that the picture means, and we will return to its other implications later when we consider Vasari's *Lives* as autobiography.

What's in a Name?

Even when Vasari is not exploiting them for their deeper meaning, names reveal a great deal of history. We might pause here to consider this history by citing just a few examples of the significance of names—observing what names tell us mostly but not always before we explore more fully Vasari's deeper meditation on the philosophy or poetry of names.

Names provide us with a map, telling us where artists were born, lived, or worked. Desiderio da Settignano, Benedetto da Maiano, Fra Giovanni da Fiesole, Benedetto da Rovezzano, and Pierino da Vinci—to give just a few typical examples—identify the towns around Florence from which artists came. Artists also took the names of places within cities or just outside of them where they lived or practiced their trade: Giovanni da Ponte had his shop near Santo Stefano a Ponte, Antonio Rossellino dal Proconsolo was named after the street in which he kept his shop, and Fra Bartolommeo was called Baccio della Porta because his family lived near the Porta a San Piero Gattolino. On occasion an artist could even be named after a work he had made, suggesting a place. Thus, Iacopo della Quercia was known in Siena, Vasari says, as Iacopo della Fonte, after his civic fountain in the Campo in front of the Palazzo Comunale.

Artists often bore their fathers' names, for example, Filippino Lippi, named after his father Filippo; occasionally, they were named after their mothers, as was Piero della Francesca. Artists were often

named after their teachers, as were Giottino and Perino del Vaga. Sometimes they or members of their families were named after famous artists before them. Giulio Romano named his son Raffaello after his teacher, and Iacopo Bellini named his son Gentile after his friend Gentile da Fabriano—so Vasari perhaps pretends. Sometimes, too, artists were named after patrons. Baccio Bandinelli named his son Clemente, also a sculptor, after his patron Clement VII de' Medici. Artists' names also reflected their professions, artistic and otherwise. Girolamo dai Libri was so called because he was an illustrator of books, and Sebastiano del Piombo took his name from his office as master of the papal seal.

Artists were frequently named for their physical attributes. Rosso Fiorentino was, as his name suggests, a redhead, and we might perhaps assume that Carota was similarly a carrot top. Masaccio was Big Tom, Hulking Tom, as Browning called him, and his friend Masolino was Little Tom. Zoppo Orefice was a cripple, as his name indicates, and Battista Gobbo da San Gallo was a humpback, as his name tells us. Artists' names also reflected their moral character, as was the case with Fra Giovanni da Fiesole, known as Fra Angelico because he was angelic. Vasari cannot resist intervening in these names as when he says that Giorgione's name, Big George, suggested the largeness of his soul, whereas his name no doubt referred only to his physical size.

If the Renaissance was the period of the revival of classical culture, this fact, too, was memorialized in names "all'antica." Baldassare Peruzzi's protégé Virgilio Romano was given the name of the classical poet, and Enea Vico received the name of the classical poet's epic hero. When Giulio Romano named his daughter Virginia, he gave her the name of one of the great heroines of ancient Rome. Aristotile da San Gallo was named after the ancient philosopher because he spoke with the gravity appropriate to a philosopher and also because he resembled Aristotle, known from classical busts, in physical appearance. Sometimes names not explicitly classical were given classical meaning. Vasari tells us that Vincenzo da San Gimignano decorated a facade after a design of Raphael's for the Battiferri with images of the Cyclops forging thunderbolts and of Vulcan making the arrows of Cupid. Battiferri means "smiths" or "beaters in iron," and in Raphael's invention their name took on classical meaning.

Names are, in short, the crystallization of history. They tell us about persons and places, about cities and streets, about anatomical and

cartographical details, about professions and works, about personality and moral character, about the cultural values of an age, and about those who were once honored. Names are clues to history lived and history imagined.

Noble Names

The history of nomenclature may be said to reverse itself, for as names emerge from things (professions, places), so also things, in the form of anecdotes, emerge from names, and in this respect Vasari is shameless. Vasari repeatedly invents tales based on names in order to emphasize the honor of these names. He pretends that Arnolfo di Cambio, son of Cambio, was the son of Lapo in order to place him in the noble house of the Lapi Ficozzi. He then goes on to say that Arnolfo immortalized his name on his greatest work, the church of Santa Maria del Fiore, by making his "arms" in the form of a frieze of fig leaves, which stood for his supposed family name, Ficozzi. In typical poetical fashion, Vasari makes this point emphatic by making the image alliterative, speaking of "fregio . . . foglie . . . fico." He also pretends that Brunelleschi belonged to the same "noble" Lapi family symbolized by the figs or "fichi," thus linking the future architect of the cathedral to Arnolfo's family and emblem. Vasari invents an imaginary artistic family and its emblem centered in the great monument that both Arnolfo and Brunelleschi helped to build. He says that Arnolfo's work at the cathedral was his "greatest" and that for it he received "infinite praise and eternal name." The "arms" that Vasari invented in this soaring genealogical fantasy are the image of Arnolfo's noble name and honor.

Vasari's fiction about Arnolfo's figs has a bearing on a well-known tale told by Sacchetti about Giotto and retold by Vasari in his life of the artist. When an oaf came to Giotto and asked him to paint his arms, as if he were the king of France, Giotto mocked him by painting on a shield, a helmet, a sword, a dagger, a lance, and various other "arms," playing facetiously on the word "armi," which means both a coat of arms (what his patron wanted) and military arms (what Giotto painted). When the simpleton complained of this, Giotto replied, "Who were your ancestors? you should be asking of yourself." Al-

though the indignant clod brought suit against Giotto, he lost the case to the painter.

This tale comments on the pretensions of those who aspire to a higher station in society than that which they occupy. Among these individuals, we might note, are artists themselves. Lorenzo de' Medici's ironic remarks to Giuliano da San Gallo make light of artists who would become so important that they would be founders of important houses. Vasari's emblematic sharing of Lorenzo's vase, as we saw in the above-mentioned portrait of Lorenzo, suggests the way in which the artist usurps an attribute of his patron, making it part of his own arms. And this invention brings us back to Arnolfo's figs, linking him to the noble Ficozzi. Clearly Vasari does not intend to associate artists with such fools as the oaf who asked Giotto to paint his arms, but we cannot quite escape noticing that Vasari's practice of celebrating the noble names of artists is strikingly like that of the clod or "goffo" who is the butt of Giotto's joke. Vasari would of course insist that artists make themselves "noble" through the "virtù" of their works. It is therefore a short, poetical step from noble works to noble names.

Spinello and Spinelli

Writing of Spinello Aretino in the first edition of the *Lives*, Vasari says that a tombstone showed the artist's "arme," which included both a Latin epitaph and the image of a "spinoso" or hedgehog, made according to the artist's caprice. A recent editor of Vasari's biography of Spinello observed that "neither Spinello's tomb nor the tombstone exists any longer." Of course not! The tombstone with its emblematic animal, playing on the artist's name and epitaph, praising Spinello as "nobiliss(imo) cvivs," is a typical Vasarian fiction, part of Vasari's campaign to celebrate the nobility of artists and their names. Spinello's "spinoso" is a picture of the painter's honored name. No matter that the hedgehog never existed, for the literary idea of it celebrates the artist's glory and fame.

Vasari continues to play on names when he writes the biography of Spinello's son Parri Spinelli. Spinelli's typically elongated and agitated figures appear "spaventaticce" or terrified. Vasari explains their fright as the result of an attack upon the painter by Parri's armed

relatives, "parenti armati," after a quarrel over money. Although he survived the attack, his fear lived on in the form of his frightened figures.

This little fiction is one of Vasari's masterpieces. It links Spinelli to Spinello through their shared terror. Like his father, terrified to death by his own Lucifer, Spinelli is frightened by his attackers. In both cases, the artist's experience is linked to his art. Indeed, the terror of the terrified Spinelli illustrates the proverb used by Vasari: "Every painter paints himself." Parri's illustration of his own fright is a corollary of Spinello's own figure causing fright in the artist. Vasari also links this proverbial truth about painters painting themselves to the saying that names are the consequences of things. Although Parri's name is a shortened form of Guasparri, Vasari, ever the witty opportunist, is punning in fantasy on his name when he pretends that Parri was attacked by his relatives, for this attack was an attempted parricide or "parricidio."

We should also recall here Vasari's tale of Parri painting the burning tongues of his envious detractors. It invokes, as we saw, the terror-filled world of the *Inferno,* and it brings us full circle back to the hell painted by his father. In three interrelated fictions—those of Spinello's Lucifer, the attack on Parri, and the burning tongues—Vasari richly orchestrates the biographies of father and son, linking them by their common infernal theme. He reaffirms through Spinello's imaginary "spinoso" and the fictitious attempted parricide of Parri the importance of names, a theme essential to the *Lives.* Vasari's way of playing on names is a reminder of his role as poet.

Litigious Lippo

Sometimes Vasari relies on the poets for the poetry of his nomenclature, as he does, for example, in the life of Lippo Fiorentino. Lippo? No, this is not the famous Fra Lippo Lippi but an obscure artist whose personality Vasari creates whole cloth out of one of Petrarch's sonnets. Vasari writes that Lippo was a litigious person and that he loved discord rather than peace. One morning, Vasari pretends, Lippo used harsh words at the Tribunal of the Merchants. For this he was attacked

the same evening, receiving a knife wound in the chest, from which he died miserably a few days later.

As the personification of litigiousness and discord, who inspires wrath in others, Lippo is himself a figure of rage, expressed through his harsh words, which result in his own downfall. Just as Parri Spinelli's terror is linked to an attack, which plays on his name, so is the attack on Lippo. Vasari's alliterative identification of "Lippo . . . litigioso" is a poetical creation based on Petrarch's *Canzoniere* 232. Anger or "ira" is the theme of this poem—the wrath that vanquished Alexander, the anger that carried off Tydeus, the anger resulting in punishment, as Valentinianus knew, the self-anger of Ajax—the rage that is a brief madness leading its owner to death, "mena a morte." Petrarch says that anger made Sulla not merely blear-eyed ("lippo") but eventually blind, and this blind rage eventually killed him. When Petrarch uses the word "lippo," he employs it in rhyme with Filippo, Lisippo, and Menalippo. This rhyme chimed in the imagination of Vasari, who created his own Lippo out of Petrarch's "lippo," associated in rhyme with rage. Vasari's litigious Lippo belongs to Petrarch's list, and now, like Sulla, he is "non pur lippo," not only blear-eyed, but entirely blind in his rage. In accord with Petrarch's conclusion, Lippo's anger leads him to death, mortally wounded for his wrathful words.

Whereas most names of artists are associated with glory, some are bespotted with vice, notwithstanding their accomplishments. Lippo is a case in point. Creating Lippo, Vasari exhibits his Pygmalion-like capacities, since he turns this artist, about whom he knows next to nothing, into a flesh-and-blood character. The creation of Lippo has even deeper significance, for Lippo conforms to the typology of the vicious artist who becomes more and more real as we approach Vasari's own times. Lippo is an ancestor of Vasari's Castagno, and both essentially fictitious characters are antecedents of Michelangelo's vicious rivals: first Torrigiani, a figure of violent rage, who really did smash Michelangelo in the nose, and Baccio Bandinelli, whose hateful malevolence is characterized in some detail in Vasari's biography.

Although the biography of Bandinelli is in many ways factual, it still includes elements of fiction, like that employed by Vasari in the lives of Bandinelli's forebears. When Vasari tells us that Bandinelli, in his rage and envy, tore up Michelangelo's cartoon for the *Battle of Cascina,* he likely invents this episode to magnify his artist's villainy.

No matter that Bandinelli probably did not tear up the cartoon, for the deed is appropriate to an artist both nasty and hateful to Michelangelo. What Vasari wants to do is create a literary portrait that will endure. Poetry or fiction is an acceptable instrument in the creation of such an enduring portrait. Vasari's fiction about Bandinelli's evil deed is like the fiction about Lippo. Both fictions assure the lasting notoriety of their subjects.

Nicknames

Vasari also tells us much about nicknames. They are everywhere in the pages of his book both in fact and imagination. In English "nickname" comes from "snicker," suggesting that there is an element of derision or mockery in them. Michelangelo referred to an interfering prelate by calling him Monsignore Tante Cose or Busybody, and he had a silly protégé called Topolino, Little Mouse. Donatello's prophet for the cathedral was called Zuccone or Pumpkin Head because of his seemingly bald pate, and Sodoma was so called on account of his predilection for beardless youths. He was also endowed with a second nickname, "Mattaccio" or Fool, because of his eccentricities and antics. Vasari's portrayal of Sodoma's Oscar Wilde–like posturing, his menagerie, including a pet crow, his fancy clothes, and stable of horses are part of this image expressed through his nicknames. No doubt Vasari poetically embellished the reality of Sodoma's character. Many of Vasari's fellow Florentines, friends and associates, had nicknames. Cronaca was so called because he was a chronicle of information in his discourses, especially in his news of Rome, and Tribolo's name expressed the artist's troubles or tribulations.

Vasari's colleague Benvenuto Cellini also dwells on nicknames in his autobiography. Implicitly commenting on Tribolo's name, he spells out Tribolo's tribulations in a comic description of how frightened the artist becomes. When he refers to our own Vasari, he calls him "Georgetto Vassellario," both twisting his family name and mocking him by referring to him as "Georgie." With greater mockery still he calls his hated enemy Baccio Bandinelli, Buaccio, playing on "bue" or ox, thus calling him Nasty Ox. Although his own name meant

Welcome, he admits that he was on occasion called Malvenuto or Unwelcome.

One of the most delightful Florentines endowed with a nickname was Niccolò Grosso, called Caparra or Earnest Money. He was, Vasari says sympathetically, a fantastic person, by which he means that he was a person of fantasy. Vasari claims that Lorenzo de' Medici, who supposedly gave San Gallo his name, endowed Caparra with his nickname. In Vasari's "novellino," the artist hung over his shop a sign with burning books, which alluded to those occasions when patrons asked for more time to pay for the works they commissioned. To this Caparra replied that he could not take on work because his account books were burning, and therefore he could not record the names of debtors. He was, in a word, obstinate, about collecting his payments—hence his nickname, for he was truly earnest about money.

Caparra belongs to the type personified by Graffione or Giovanni di Michele Scheggini, who is pointedly introduced in the life of Baldovinetti. In contrast to Baldovinetti, who died in poverty because he gave all his money to his friends and generously left his drawings in a chest to the Ospedale di San Paolo as a donation, Graffione is preoccupied with money. In another of Vasari's delightful and instructive tales, Lorenzo de' Medici says to Graffione that he wants to continue the work on the mosaics at the Baptistry. The artist replies—"You don't have the necessary masters." Lorenzo in turn responds—"But we have the requisite money." Graffione has the last word, saying, "Ah, Lorenzo, money doesn't make artists, artists make money!" Like Caparra, Graffione is earnest about money and, as his name suggests ("graffia" means hook or claw), Graffione is grasping.

In his fictions about Caparra and Graffione, both of whom are, as he says, bizarre, Vasari creates little Boccaccesque tales that evoke Dante's hell. Just as Boccaccio looked back to Dante's *Inferno,* for example, in his story about Ciacco's gluttony, Vasari looks back to *Inferno,* placing Graffione implicitly with the grasping, money-grubbing barrators of *Inferno* XXII, or more strictly speaking with the funny devils who mock such greed, appropriately punishing them with giant hooks. Graffione's very name recalls the devil Graffiacane, Dog Claw, who belongs to the legion of comically mocked devils— Cagnazzo, Draghignazzo, Farfarello—led by Malacoda, Evil Tail or Bad Ass, who used his ass as a trumpet in the famous infernal fart that is the finale to Canto XXI. Like these dog- and dragon-like devils,

Graffione is bestial. He eats at a table set with cartoons for paintings, used as tablecloths, and he sleeps in a bed of straw rather than of linens.

We generally assume that Vasari's stories about Caparra and Graffione are true, perhaps supposing that Vasari had them either from lost texts or through oral tradition. Not inconceivably, these stories do in some way reflect on the real character of his subjects. Yet we miss the full significance of Vasari's fiction if we fail to see how he has placed his characters implicitly in the imaginative universe of Dante's poem. We are to understand their laughable and brutish ways in relation to the comic aspect of the *Inferno*. Like Caparra, whose burning books evoke the greed and flames of hell, Graffione, in his comical vice, suggests the ridicule of Dante's hell. Exploiting such connections, Vasari allows us to imagine Graffione joining Graffiacane in the service of Old Nick.

Rabelaisian Play on Names

Sometimes Vasari plays on the names of places, explaining their very origins. In his life of Cimabue, he creates an elaborate fiction that explains how Borgo Allegri got its name. When Cimabue painted a Madonna and Child, as the story goes, the Florentines came to see it and were filled with "allegrezza," whenceforth the name Borgo Allegri. In Vasari's story the picture is a kind of epiphany, and the joy he describes is like the heavenly joy or "allegrezza" of which he speaks elsewhere, when he writes about paintings of the Epiphany of Christ. His fanciful etymology of Borgo Allegri belongs to an extensive poetical tradition on the origins of names that we also find in Rabelais.

We find this tradition, for example, in *Gargantua* XVI, where Rabelais pretends that la Beauce got its name when Gargantua, beholding the beautiful place, proclaimed: "Je trouve beau ce." The wordplay here depends on an implied pun, since a short time before Gargantua's huge mare had destroyed the flies of the oxen or "mousches bovines" of la Beauce. Rabelais is playing on the root of "bovine" or "bos," which in Latin rhymes with Beauce.

Rabelais's explanation of the origins of la Beauce comes directly before his more famous explanation of how Paris got its name, when

Gargantua, pissing on the city, created a flood. The citizens had been drenched "par ris," in sport or for a laugh. Hence the city's name. The laughter of the Parisians is less delicate or celestial than the joy of the Florentines in Borgo Allegri, but both tales are poetic fancies on the origins of place-names.

A micturitional merriment related to Rabelais's pissing "par ris" is found in the art of Vasari's friend Giulio Romano, who painted a putto making a "pipi" in the Palazzo del Te in Mantua in the very period when Rabelais wrote about Gargantua. The putto is a parody of Mantegna's similar putti in the Camera degli Sposi and creates the fiction that he is pissing on the spectators below him. More than this, however, he suggests a play on the artist's name, since Giulio's family name was Pippi. The putto might not exactly be a signature in the sense that the vase was for Vasari, but could Giulio di Piero Pippi have painted a putto making a "pipi" without thinking of his name Pippi?

Also Rabelaisian in spirit is the play of Vasari's Venetian colleague Titian on his own name in his profoundly Rabelaisian painting of the Andrians—a goliardic celebration of wine, love, and song, a joyous and sensuous image. Although he signs his name "Ticianus" on the scarcely covered breast of the woman voluptuously reclining in the foreground, this form of the signature is interchangeable with "Titianus," which Titian used more often elsewhere. Since the *t* and *c* are interchangeable, one form of the signature stands for the other. Painting his name on the breast of the reclining woman, the painter, rakishly, if not subtly, called attention to the fact that her "titta" was emblematic of his name. Titian's punning autograph takes on added significance, as if the strokes of his brush become caresses of the very flesh he has rendered out of "colore," as if he were a modern Pygmalion stroking his very creation. Not only is the sensuousness of Titian's signature Rabelaisian, but so is its verbal wit—a wit related to the countless "giuochi" or jokes on names in the pages of Vasari. The painting is in every sense a signature piece.

Uccello's Birds

"Who has scared them away?" Italo Calvino once asked. Where are all the birds that Vasari said Uccello painted, the "uccelli" after which he

was named? Certainly they are not in his famous paintings of the Battle of San Romano! No matter that we do not see Uccello's "uccelli," for Vasari suggests that Uccello was himself an "uccello." Let me explain.

In the language of Boccaccio, Sacchetti, and Vasari, an "uccello" is someone who is a bit simple, who is fooled or "uccellato," as was the simple courtier in the story of Giotto's O. In Elizabethan English, one spoke of such an individual as a gull, one who was gulled. When we speak of a loon, dodo, or booby, we are also speaking of this type of simpleton. Even when we speak of a dupe, we refer to such a bird-brain since the word is said to come from "upupa," the Latin for the bird known as the hoopoe. Boccaccio's Calandrino, who was duped over and over by Buffalmacco, was such a character, as was Bibbiena's Calandro in the comedy called "La Calandria." A "calandro" in Italian is a lark. Giotto painted such a figure in the Arena Chapel, where he depicted *Folly* with a crown of feathers, indicating that he was, as we would say, a featherhead. Franco Sacchetti plays on the feathers of a bird, inventing the birdbrain, Basso delle Penne, the Low One of the Feathers. In one tale Basso climbs into a cage, becoming a bird. Sacchetti also invented, we recall, the gullible Capo d'oca or Silly Goose.

But what about Paolo Uccello? Although Vasari loves him for his caprices, subtlety, and "ingegno," he constantly chides him, mocks him, and teases him for his simple ways. He tells us that Donatello ridicules his perspective studies, saying that he leaves the certain for the uncertain, and Donatello later pokes fun at him for uncovering his work when he should cover it up. The simple Uccello says, we recall, that he does not know that he is not cheese rather than Paolo, given all the cheese he is fed at San Miniato. In the most famous of all of Vasari's stories about the artist, he does not come to bed when his wife calls, replying, as if speaking of his true wife or mistress, "O what a sweet thing is perspective." "Dolcezza" or sweetness is a word that poets often used to describe their beloved.

Vasari's Uccello is an ambiguous character, praised for his caprices or perspective studies but mocked for his self-delusions. He becomes in his solitary obsessiveness a sort of wild man or "selvatico," and it is worthy of note that when Vasari later condemns the deformities of Pontormo's last works, he compares the artist to Uccello. Like Uccello, Pontormo left the certain for the uncertain. Uccello, Vasari claims,

even fooled himself, "ingannassi," by painting the perspective incorrectly in one of his frescoes in Santa Maria Novella. The whole point of Vasari's charming biography of Uccello—an imaginary character who is made real to us by his Pygmalion-like creator—is that Uccello *is* a bit of an "uccello." Fooling himself, deceiving himself, Uccello embodies his own avian being. This is the deeper sense of Vasari's notion that every painter paints himself: not that Uccello painted many birds, but that he was "uccellato." Leaving the certain for the uncertain in his perspective studies, he gulled or duped himself.

Wordplay

In life and after life, Vasari plays on the meaning of his subjects' names. In a positive vein, he tells us that Signorelli, a true "signore," was a "gentiluomo" and that Vittoria deserved the palm, meaning of course the palm of victory. Names could have negative meaning, and Tasso "tassò" or taxed his friends with censure. On other occasions still, Vasari simply seems to play with names for fun. Gian Barile, he says, made woodwork decorations in the Stanza della Segnatura where "botti" were stored. A "botte" is a form of "barile" or barrel. When Vasari says that Botticelli painted a Bacchus with a "barile" (that is, a "botte"), can it be that he is alluding to the painter's name? Is Vasari referring to the fact that Botticelli appears among the "big drinkers" in Lorenzo de' Medici's poem *I Beoni?*

Vasari pretends that Pollaiuolo's first work was a quail adorning Ghiberti's Baptistry door. Why? It is only appropriate, after all, that an artist who is the son of a poulter, as his name suggests, should begin his career with the image of a fowl. When Vasari says that Perugino was so obdurate that he had a head of porphyry—the hardest of stones—he plays on the meaning of Perugino's first name, Pietro, from "petrus" or stone. When he emphasizes the ascent of Torrigiani, using the verb "levare," which means elevation, he plays on the verb "torreggiare," to tower. Similarly, when he speaks of Bramante realizing the ambitions of Pope Julius II, achieving the pope's "very great desire," he alludes to the verb "bramare," which means such desire. Sometimes names take on meaning antithetical to the character of their bearers. Vasari, who did not like Amico

Aspertini, says that the artist was envious of others. Envy or "invidia" is the opposite of friendship. Amico was scarcely the friend that his name "amico" meant. He was not like Buonamico or Good Friend Buffalmacco, who, as Vasari says, was most companionable.

Vasari's play on names is often very freely associative and without significance. When Julius III was crowned pope, Vasari says, he mounted his horse ("montato") in order to travel to Rome, playing on the pope's birthplace, Monte Sansovino, on his family name, Del Monte, and on his "impresa" or emblem, which was a series of "monti" or little mounts. Saying that Polidoro worked during the golden age of Pope Leo X, the "età d'oro," he invokes the golden sound—"doro" of Polidoro's name. When he observes that Francesco il Torbido painted a portrait of Francesco San Bonifazio, called il Conte Lungo, Vasari plays on his name by adding that on account of his "long body," it took him a "long time" to paint and, thus, he never finished it. Here Vasari is almost crossing the very threshold of nonsense.

On occasion Vasari projects names with unconscious meaning onto individuals. He says that Desiderio da Settignano made a tombstone of a certain Giorgio, a famous doctor and secretary of the Signoria—projecting his own name on this distinguished citizen who was in fact called Gregorio. Could it be that Vasari's famous, enthusiastic description of Donatello's *Saint George* has just a little to do not merely with the vivacity of the work but also with his enthusiasm for Donatello's vivid portrayal of his holy namesake? In his life of Andrea del Sarto, to whom he was especially devoted, Vasari says his works gave him a "gran nome" or great name. Immediately before making this statement he says that Sarto made a Holy Family for Andrea Santini, whom he calls Andrea Sartini in the first edition of the *Lives*—no doubt in unconscious response to the artist's "gran nome."

More often than not, however, Vasari is very conscious of his play on names. He says, for example, that Sarto painted a Saint Sebastiano from the belly up, which was very beautiful. Whereas he often speaks of Sebastiano, here he calls the saint Bastiano, developing the alliteration, "Bastiano dal bellico in su bello." He is also playing of course on the relation of "bellico" for navel to "bello" for beautiful. Immediately before this verbal caper, Vasari says that Andrea was asked to paint a facade in the Piazza del Podestà with certain rebels who had fled Florence. Because he did not want to have the same name as Andrea del Castagno, who was called Andrea degli Impiccati, Andrea of the Hung Men, after similar paintings, Sarto gave the job to his assistant

Bernardo del Buda. Or so Vasari pretends. This fiction is a reminder that for all the play on names, for all the wordplay, often frivolous, if not silly, names were magical. Names create or give form to a person's very being, to his or her fame and glory. They are deeply consequential. Sarto, Vasari is saying, did not want to have the identical name as the wicked Castagno. Commenting thus on a name Sarto never acquired—on Andrea degli Impiccati—Vasari is thus embellishing his fiction of the evil Andrea del Castagno.

Love of Language

Having already seen numerous examples of Vasari at play—his play on words and names—we should further observe that these are not isolated jests, for they are part of Vasari's total love of language woven through his book. It is hardly possible to turn a page of the *Lives* without finding a choice epithet, rhyme, verbal joke, or alliteration. Such alliteration ranges from *a* to *z*, from the "allegrezza" of "angeli" or celestial joy of angels to the name of Zaccaria Zacchi. Vasari did not invent Zacchi's name, but like Dello Delli, this name is a reminder of the delight in alliteration, which is part of his culture, part of the genius of his language. Even when he does not find alliteration in a name, he can create it, as when he speaks of Simone Martini as Simone Sanese. When he refers to Gutenberg, he does not call him "tedesco" for German but Giovanni Guittenbergh germano, a more poetical name.

Vasari delights in alliteration, speaking of Buffalmacco as "Buonamico burevole" (from "burla" for jest), and when he talks about Starnina's fanciful play on forms he refers to "Gherardo . . . ghiribizzando." He says, too, that Lorenzo di Bicci added various colors to the gray robes he painted, "abiti bigi," making play on "Bicci" and "bigi." When Vasari says that Brunelleschi invited Donatello to dinner ("desinare"), Donatello saw his friend's Crucifix, was shocked, and asked, What "disegno" or scheme is this? Vasari brings "desinare" and "disegno" into playful relation to each other, using a key word ("disegno") in the lexicon of art. Here the word can be taken to mean artifice, since Brunelleschi had extended his invitation as a ruse in order to shock his friend with his work of art.

For Vasari one artist is "strana e stravagante," another creates

"maraviglie" and "miracoli"—marvels and miracles. Sometimes these alliterations render an implicit iconographical conceit. When Brunelleschi was building the dome of the cathedral of Florence, his brain was, Vasari observes, "often suspended" in thought, "spesso sospeso." Here the comparison of a skull to a dome (not without precedent) is particularly ingenious when applied by Vasari to the very creator of the dome of Florence. The structure of the cathedral's dome mirrors the structure of its creator's head, housing his "ingenium." Every painter paints himself. Alliteration also adds to the energy of a significant action or choice phrase. Brunelleschi says that his dome would stay up like an egg resting, we remember, on its broken bottom. He makes his demonstration, Vasari says, by giving the egg a blow to its bottom, a "colpo al culo." Michelangelo quips that Baccio d'Agnolo's addition to the cathedral dome looks like a "gabbia da grilli" or cricket cage.

Vasari is always playing with the very name of Florence. In his fictitious epitaph for Taddeo Gaddi, he refers to Florence as joyous Flora or "Felix Flora." (Was Botticelli, when he painted the smiling Flora of his *Primavera*, alluding to such an alliterative conceit?) Vasari says that many artists flowered in Florence, "fiorirono in Fiorenza," playing on the supposed etymological relation of Fiorenza to "fiori" or flowers. Saying that the Graces adorn Venus in the *Primavera*—"la fioriscono"—he comments on the painting's floral subject and, saying that the Graces are painted "con grazia," with grace, he suggests (to borrow a phrase Vasari uses elsewhere) their "graziosissima grazia"— the greatly graceful grace of the Graces. Worthy of the city of flowers, Vasari is forever commenting on various friezes of flowers, fruits, and fronds—fregi di fiori, frutte, e frondi. His own poetical phrases become similar flowery forms in the garden of his florid prose, which reflects his "valore e virtù," which is "ornato ed onorato"—to borrow other choice epithets of his.

Ingenuity and Ingenuousness

Vasari exhibits the extreme ingenuity of his wordplay in his biography of his lovable and ingenuous disciple Cristofano Gherardi. He tells us

that Gherardi worked on decorative grotesques along with Vasari's cousin Stefano Veltroni dal Monte San Savino. Both artists were deficient, Vasari says, for Gherardi failed to bring his work to completion ("fine"), whereas Stefano's lacked a certain finesse ("finezza"). Working together on a frieze, they learned from each other and, finally ("finalmente"), Stefano achieved "finezza," making his works with more finesse, and Gherardi learned to finish ("finire") his work. Vasari's play on "finire" and all its senses of finish, finality, and finesse is itself a charming paradigm of his literary Mannerism, which stands against the delightful innocence of Gherardi.

Gherardi, we recall, was indifferent to fancy clothes or finery of any kind. When he got stuck in his stockings and could not remove them, he cursed them, saying that they made him a slave in chains. Echoing this theme of servitude, Vasari notes Gherardi's comment that he liked the name of the slave of Messer Sforza, which was simple, just the letter *M*. A short name, he thought, was a beautiful name, unlike all those long ones that take an hour to pronounce. Whereas Vasari delighted in the elegant, Gherardi was of more simple tastes. Nevertheless, Vasari delighted in Gherardi's blunt remarks, his "linguaggio borghese," which would have made even a plant laugh.

Vasari's *Lives* is full of all those long names that the simple Gherardi detested: Michele di Ridolfo del Domenico (which tells us that Michele Tosini took the name of his teacher Ridolfo, son of Domenico Ghirlandaio); Nanni di Prospero delle Corniuole, which reveals that Nanni's father worked on gems; Francesco di Giuliano dal Prato, which says something both about an artist, his family and abode; Avveduto del Cegia Vaiaio, also called Avveduto dell'Avveduto Vaiaio—a name Vasari especially liked, since Avveduto dell'Avveduto Vaiaio is a wonderfully alliterative name. The charm of Vasari's story about Gherardi's distaste for long names is that it comments ironically on Vasari's own delight in long, flowery names. The "novellino" about Gherardi's philosophy of nomenclature also comments on the universality of Vasari's view of things. For all the artifice and "ingegno" of his own mannered language, he also likes the pithy slang of his ingenuous disciple, who liked the name M in all its simplicity as much as Vasari liked Giotto's O in all its complexity. In the end, Cristofano Gherardi's comment on the beauty of brevity in names is a serious "scherzo" on just how important names are to Vasari—to Giorgio di Antonio Vasari Aretino, whom Gherardi might just as well have called G.

The Life of Morto da Feltro

Gherardi's M leads to one of Vasari's most singular artists worthy of the letter *M*. I speak of Morto da Feltro. Who was Morto da Feltro? According to Vasari, he was a painter from Feltro in North Italy, who traveled to Rome in the late fifteenth century, where he studied the ancient grotesque manner of painting, after which he went to Florence, where he was received by and worked with Andrea di Cosimo de' Feltrini. After painting with Feltrini for a time, he grew restless and went to the Veneto, where he worked with Giorgione, before traveling to Friuli. Like Giorgione, he indulged in pleasures of the flesh. He finally abandoned painting for a military career, however, wishing, according to Vasari, to "acquire greater name and position," and he died ("venne morto") after fighting valorously in the Battle of Zara.

Art historians have labored mightily to reconstruct Morto's problematic *oeuvre* in numerous specialized essays, and Sydney Freedberg has placed his work in its broader context, speaking of Morto's grotesque works in the magisterial pages of his *Painting of the High Renaissance in Rome and Florence*. I say that his *oeuvre* is problematic because there is no signed or documented work by the artist. Art historians have had to suppose that Vasari's Morto is a certain Lorenzo Luzzo da Feltro, who signed only one work, now lost—not exactly a secure basis for reconstructing the work of an artist. If they had paid attention to Vasari's poetical vein, to his philosophy of nomenclature, they would have come to a rather different conclusion: that Morto never was! Who ever heard of anybody named Morto or "Dead"! A further clue to his fictitious identity is to be found in Vasari's playful claim that he wanted to "acquire a greater name," that although he died and was "morto," he would never be "morto" because of the fame of his works, which live in memory after his death. In fact, as we see, his death was necessary for his birth, for in his death he woke eternally to live for us through Vasari's fiction.

The reader who reads Vasari not merely as an art historian but also as a literary artist in his own right will recognize further clues to this fiction. Vasari suggestively traces Morto in full career from North Italy to Rome, then Florence, and back to the Veneto. But whose career does this re-create? That of Giovanni da Udine, the greatest and most famous master of the very speciality followed by Morto—grotesque

decoration. Just as Vasari made up the lives of his other Trecento and Quattrocento artists—Buffalmacco, Castagno, and Uccello—he made up Morto's, in this case out of Giovanni da Udine's. Why? Since through Morto's career, based on Giovanni da Udine's, he explains how Feltrini developed his own grotesque style in Florence.

Then, too, there is the not-accidental relation of the names Feltro and Feltrini. Vasari loves to play with similar names. Benozzo (Gozzoli) was sometimes taken, he says, for Melozzo (da Forli), and he places Pesello and Pesellino in proximity to Pisanello. Why Feltro with Feltrini? Vasari thereby plays, as his readers should recognize, on one of the most famous and extensively commented upon phrases in Dante's poem, the mysterious reference in *Inferno* I, "tra Feltro e Feltro," between Feltro and Feltro. Vasari gives a new and very witty twist to the phrase in writing of Feltro e Feltrini.

In his first edition of the *Lives* Vasari made up an epitaph for Morto, eliminated in the revised edition, where it is translated directly into Vasari's prose narrative. It begins, "Morte ha morto me che il Morto son"—Death has killed me who am Morto. Vasari goes on to say in the epitaph that, despite his death ("morte"), his (Morto's) works live. Is this not a supreme commentary on Vasari himself, on his "vita" or life of Morto, who lives in memory, although he never lived in fact? Vasari's achievement in giving life to Morto is in a sense even greater than that of Michelangelo in making his statues of the Medici dukes. Michelangelo did not portray the dukes as they appeared, because it would not matter a thousand years later, as he remarked, how they once looked. Nevertheless, his figures refer to somebody. Vasari creates his hero, with higher fantasy, out of Nobody.

So powerful is Vasari's poetical philosophy of nomenclature that it has determined the attribution to Morto of a portrait in the Uffizi, said to be a self-portrait of the artist. Painted in an early sixteenth-century and North Italian style, the portrait conforms to Vasari's biography of the artist. The portrait is no doubt given to Morto not on the basis of style alone (for what by the artist is there to compare it to?), but on the basis of its iconography. The sitter in the portrait is holding a death's head, a traditional symbol of the vanity of things, of mutability, of death. Those who attribute the portrait to Morto no doubt respond, if unconsciously, to the relation of the attribute to Morto's name. They are unwitting followers of Vasari, who believed that names are consequential.

Vasari's play on Morto's name recalls Petrarch's play on himself as "pietra morta" or Strozzi's Petrarchan reference to Michelangelo's ability to make dead stone come alive: marmo morto vivo. Like Petrarch, Vasari is a Pygmalion, bringing his own creation, Morto, to life in the "vita" of Morto. He plays the same role that he says Petrarch had when the poet assured the fame of a great artist. In Petrarch's case, we recall, the artist was Martini. It is not inconceivable that the portrait of Laura of which Petrarch spoke was a fiction, since Laura herself was likely a fiction. Morto belongs to this fictitious lineage. If Vasari brought Morto to life thanks to Petrarch and Dante, he also relied on Ennius, who wrote an epigram that would later be used by Dante: "Nemo me lacrimis decoret nec funera fletu./ Faxit. Cur? Volito vivus per ora virum": Let no one adorn my funeral with tears or accompany it with weeping. Why? I fly alive on the lips of men. Morto, not "morto," is alive in just this way, "vivus per ora virum," alive on the lips of art historians, who continue to speak of his works, as if they ever existed. Death be proud! Long live Morto! And long live his Pygmalion-like creator, alive in the *Lives*. Evviva Vasari, scrittore straordinario e stravagante.

Leonardo's Lost Lion

The philosophy of nomenclature affords us a perspective on works of art otherwise thought to be of little or no significance. Such is the case in Vasari's discussion of Leonardo's lost lion. Vasari tells us, in a story repeated by Lomazzo, that when the king of France came to Milan, Leonardo was asked to make something bizarre and that the artist constructed a lion, which took several steps before its chest opened, revealing itself to be full of lilies.

How curious, how strange indeed, that a work that should be seen as important—a work for the king of France—although lost, is virtually uncommented upon in the recent scholarly literature on Leonardo. Leonardo's lion is of interest because it reflects the artist's status as magician. It was magicians, according to tradition, who made such marvelous automata, and Leonardo's magical invention of a walking lion—a wondrous mechanical device—is consistent with his capacity to make, as Vasari says elsewhere, the impossible possible. But

what did the lion mean? The lion was a regal beast, and the lily or "fleur-de-lis" was the royal flower of France. The lily-laden lion can be seen as an offering to the monarch, emblematic of the king himself, a gift that lionizes him.

But is that all? The lion is also the symbol of Florence. We recall that lions were kept in Florence in the Via de' Leoni and statues of the Florentine lion or Marzocco were erected in the Piazza della Signoria, of which Donatello's is still preserved. Moreover, the lily was the flower of the Florentines, their beloved "giglio," which adorned the Palazzo della Signoria, as it covered the "fiorino" or Florentine coin. The lion loaded with lilies could also have been an offering to the king of France symbolizing Florence, the adopted city of the artist from Vinci. After all, Leonardo was known as Leonardo Fiorentino.

But we must ask, Is that all? If Pope Leo X, who met Francis I in Bologna in 1515, could take a lion as his emblem, why could not Leonardo, since his name, like Leo's, refers to a lion? Leonardo, we know from his notebooks, was fascinated by lions. He gives an accounting of how many lions were kept in Florence at one time. He studies their anatomy, remarking on the structure of their eyes and the coarseness of their tongues. He clinically observes how a lion held a lamb in its paws and licked all of its wool off before swallowing it. Lions, Leonardo adds, were known to cover their tracks—a point of special interest to the artist, since he was leonine in his secretive handwriting. Was the lion that Leonardo made a sort of triple entendre—a symbol of the king to whom he gave it, a symbol of the city where he worked, and an emblematic reference to his own name?

Yet again we must ask, Is this all? That is, did Leonardo really make this lion or is it a fiction invented by Vasari, in which case its meaning or meanings are Vasari's own. I leave it for the reader to decide, but before leaving Leonardo's lion alone, I want to suggest how Vasari might have invented it. First, he might have created it out of Donatello's *Marzocco*, then in the piazza, since on the lion's shield was a lily, significantly chest high. Second, the story bears a relation to the famous fiction that follows, according to which Leonardo died in the arms of the king of France, as if one monarch supported the other—the recipient of the lion cleaving to its leonine maker. But enough of such speculation. No wonder art historians, especially Leonardo's scrupulous and assiduous scholars, have steered clear of Leonardo's lost lion. Nevertheless, wherever the remains of Leonardo's lion are

today, I hazard the guess that they are not far from the tomb of Morto da Feltro.

Why Mona Lisa Smiles

Our survey of wordplay or the play on names from Parri's parricide to Leonardo's lion prepares us, finally, to answer the question: Why does Mona Lisa smile? Vasari tells us that while he painted her Leonardo employed "buffoni" or jesters to divert her and musicians who sang and played instruments, because he wanted Mona Lisa to be happy or "allegra" and not appear with the melancholic expression so often found in portraits. Leonardo succeeded, Vasari suggests, for her smile in the final portrait was so "pleasing" that it was "more divine than human" and was held to be a "marvelous thing."

For us, Mona Lisa's smile is seemingly more complex or problematic. In the imagination of the Romantics and of some today, the beauty of Mona Lisa is associated with terror, but even so the idea of the connection of her beauty with terror has its roots, as we have seen, in Vasari, since he says that Leonardo's artifice in rendering her would create fear in any daring artist. The force of this view, magnified by the Romantics, by Baudelaire and Pater, is so great that many still see her as sinister. Some now even prefer to see what was once regarded as a pleasing smile as a baleful sneer. Be that as it may, the epitome of reflections on Mona Lisa's smile is the classic essay in which Freud suggests that her smile, like those of Leonardo's smiling Mary and Saint Anne, reflects the memory of the artist's mother. The smile in Freud's interpretation is both pleasant and treacherous. Although his essay has been discredited in detail by art historians, the force of the intuition that informs it remains, and Kenneth Clark, for one, accepted its essential validity.

We will never know for sure whether Mona Lisa's smile in some way is a remembrance of Leonardo's mother's smile, but even if it is (and how can it not be?), we still might speculate on the more immediate reason why he painted her smiling. It is often and rightly observed that Leonardo relied on the smiling faces of Verrocchio and that he was also responding to the conventions of Tuscan poetry, in which the

smile of the beloved is a radiant expression of her divinity or loveliness. These are viable sources of the smile, but what of Leonardo's motives or intentions? Let us turn back to Vasari's "novella," and the implicit explanation or interpretation that informs it. "Buffoni" or jesters are jokers (to use the language of playing cards), and their jokes or "giuochi" are the cause of merriment, "allegrezza," in Mona Lisa. This implication of the story brings us to the name of Leonardo's sitter, for if she is popularly known as La Gioconda, this is because of her name, since, as Vasari says, she was the wife of Francesco del Giocondo. Giocondo? Yes, gentle reader, you see: "giocondo" means jocund, merry, glad, joyous, "allegro." Mona Lisa's smile, Vasari is saying, expresses the very quiddity of her jocundity. Vasari wittily weaves together two disparate but related words here, for "giocondo" comes from "iocundus" in the Latin, and ultimately from "iocus" or "gioco," which he implicitly and cunningly extracts from it.

Vasari's association of Mona Lisa's smile with jocundity is like his play on names in the description of Correggio's *Madonna and Child with Saint Jerome.* Here the angel who smiles, Vasari says, would make even a melancholic person merry or "allegro" (from "rallegrare"). This is a reference to Correggio, because the painter was himself a melancholic person, as Vasari said, and because his name was Allegri. The smile that has the power to make one "allegro" is thus related to Antonio Allegri da Correggio's name, just as Mona Lisa's smile expresses her jocundity, that is, her identity as the wife of Francesco del Giocondo.

Is all this mere wit and wordplay on Vasari's part, or does it, in light of the philosophy of nomenclature, point toward Leonardo's intention? We know from Leonardo's writings and paintings that he pondered the meaning of names—hence his famous quip alluding to Petrarch's Laura that if the poet loved bay leaf ("lauro") so much, this was because it is good with sausages and thrushes. He also plays in one of his jests on the name of a lady called Madonna Bona, Madam Goodwoman. When a sick man heard about this lady, he asked that she be brought before him, because he wanted to see a good woman before he died.

I do not know how Leonardo would have painted Madonna Bona, referring to her "bontà" or goodness, but we know that he did paint the names of at least two women. In his portrait of Ginevra de' Benci

he surrounded his sitter with a halo of "ginepra" or juniper, emblematic of her name Ginevra, and in his painting of Cecilia Gallerani, he depicted his subject holding an ermine or "galée" in Greek, referring to her name Gallerani. It is possible by analogy that Leonardo painted Mona Lisa with her slight smile as an expression or sign of her jocundity. Vasari's tale may therefore be more than an amusing story, for it may well point to Leonardo's own intention to paint La Gioconda's jocundity. Vasari's "novella" is a delightful interpretation disguised as fiction. Even if the skeptic doubts either that Mona Lisa smiles or that her smile alludes to her name, as Vasari suggests, this skeptic is forced to acknowledge that Vasari's tale is a response to the portrait not long after it was painted. As such, it is a historical document, if you will—a record of how Renaissance beholders could imaginatively respond to and thus interpret works of art.

Mona Lisa at Court

We might pause to consider whether there are not other historical implications in Vasari's tale of how Leonardo painted Mona Lisa. By telling us that Leonardo employed buffoons and musicians, Vasari is suggesting that Mona Lisa is like a queen at court being amused or diverted by a princely painter. This interpretation is consistent with Vasari's characterization of Leonardo's "regal" character and by his concluding tale of Leonardo dying in the arms of Francis I, as if he were a king greater than the king of France himself.

When Vasari creates a court setting for Mona Lisa, he projects this context back onto her from the present in which he writes—that is, from the Medici court. In other words, although Leonardo painted Mona Lisa during the Soderini Republic, Vasari, writing during the rule of Duke Cosimo de' Medici, can easily envision Leonardo as a court painter in Florence by analogy to his own activity as court artist there. Moreover, his understanding of the meaning of Mona Lisa's smile as emblematic is related to his own practice of painting emblems in his portraits of Lorenzo de' Medici and Duke Alessandro de' Medici, in the courtly Medicean circles of Florence during the 1530s. How Vasari describes or interprets works of art depends on his own

experiences, indeed on how he lived his own life, and it is toward this implication of the *Lives* that we must gradually turn. For his book, as we will come to see, is a monumental autobiographical work, a record of crucial moments, events, and experiences in its author's own life.

A Great Woman

Leonardo's magisterial portrayal of the regal Mona Lisa, who dominates the landscape before which she is seated, is a creation that stands in the tradition of idealized women celebrated by the Tuscan poets. She takes her place, as has often been suggested, alongside Dante's Beatrice and Petrarch's Laura. When Vasari further describes the Mona Lisa by cataloguing the beauty of her face, detail by detail—her forehead, eyes, nose, and mouth—he appropriately uses the language of the Tuscan poets to bring out her divine grace and loveliness. The Mona Lisa is not only a great painting, but Vasari's great description, which reverberates in the pages of Pater, Freud, and lesser figures, including professional art historians, contributes to her enduring fame as a great figure. She is not herself great but is made great through Leonardo's art, taking her place in the *Lives* among other great women. Of these, none is greater than Margherita Acciaiuoli.

Margherita Acciaiuoli? Unlike Mona Lisa, embodied in Leonardo's painting, Margherita Acciaiuoli, a near contemporary of Mona Lisa, is a largely forgotten figure today—except by those who happen to concern themselves with Pontormo and Vasari's biography of him. It is in this life that we encounter her giving a rousing, noble speech as she defends a painting by Pontormo and others made for her marriage bed. Vasari's account of Pontormo's painting and of Margherita's oration is a compound of fiction and criticism, the full significance of which has been previously overlooked by Vasari's readers. When we carefully explore these pages dedicated to Margherita Acciaiuoli, however, plumbing their depths, we come closer to understanding Vasari's literary genius and value as a historical source, even though he is writing fiction. Fiction in Vasari, as we have seen, is never mere fiction.

Pontormo's Most Beautiful Painting

The painting defended by Margherita Acciaiuoli and described in some detail by Vasari is Pontormo's *Joseph in Egypt*, now in London, which was part of the decorations for and around the marriage bed of Margherita and her husband, Pierfrancesco Borgherini. Pontormo's painting is seen today by art historians in a way very different from that in which Vasari perceived it. The painting is now regarded as the paradigm of Mannerist anticlassicism. For one scholar it is marked by "irrational jumps of scale" and "strangeness," for "throughout the whole picture . . . runs a strange terror resulting in an almost physical terror." For another scholar it is a work of "caricature" and "eccentricity," "abnormality" and the "irrational." Is this the same picture that Vasari describes?

Vasari sees Pontormo's picture as a manifestation of "genius" and "virtue," reflected in the "vivacity of the heads" and "in the composition of the figures and in the variety of their attitudes and the beauty of invention." He singles out the detail of the figure of a boy, saying it is "vivid and marvelously beautiful." If this work were larger or a wall painting, Vasari adds, it would be difficult to find a major painting of comparable "grace, perfection, and excellence." Vasari adds, "I would dare say that no other painting surpasses it." This phrase, "io ardirei di dire," in the Italian, is another of those memorably alliterative phrases that Vasari likes so much. It plays both on the repeating "di . . . di . . . di" sound and on an implicit pun, since "ardirei" contains within it "direi," which means "I would say."

At the beginning of his biography of Pontormo, Vasari claims that Raphael, seeing the young painter's work, was filled with infinite marvel and prophesied Pontormo's future success. He also quotes Michelangelo, who supposedly said, "This youth will carry this art into the heavens if he lives and continues in this fashion." Pontormo's painting of Joseph was such a youthful work. One wonders whether Vasari did not put these words of prophecy and praise into the mouths of the greatest living artists in order to emphasize his future rise and fall. For if Pontormo showed such talent and promise early in his career, and excelled for a time, he ended badly, and Vasari emphasizes that his final work at San Lorenzo was without "doctrine" and

showed "confusion." "One does not see at all," Vasari adds, "the singular grace and excellence that marked his other works." Vasari is making his point by playing on Pontormo's name, for the phrase "at all" is "punto punto," echoing the name of the painter whom Vasari calls "Puntormo." Vasari is saying that the painter was no longer himself— punto punto Puntormo.

Between the prophecies of his future greatness, real or imaginary, and the decline of his last years, Pontormo triumphed in such works as the *Joseph in Egypt*. Today we see the Capponi Chapel altarpiece as the painter's "capolavoro." Vasari, we should note, however, saw the Joseph painting as the artist's masterpiece: "it is deservedly esteemed by all artists as the most beautiful picture that Pontormo ever made." Vasari saw Pontormo's work not as we do after Expressionism as a work of terror and irrationality. Quite the contrary. He saw Pontormo's picture as the epitome of "bella maniera," an achievement of refined beauty and grace.

The Meaning of Pontormo's *Joseph*

Pontormo's painting was part of a grand series of fourteen panels made by Sarto, Granacci, and Bacchiacca, placed in rich ornamental wooden frames on or next to the bed of Pierfrancesco Borgherini to celebrate, as we have seen, his marriage to Margherita Acciaiuoli in 1515. The entire decoration was very important to Vasari, who comments extensively on the contributions of the other artists to it in their respective biographies. Given its importance, we might stop to ask ourselves, What did this decoration and Pontormo's contribution to it mean?

On the whole, we do not think much about the original meaning of decorations of beds or bedrooms, because most of these beds have been dismantled and the panels that adorned these chambers have been dispersed. Whereas essays are written on such specific conventions as the portrait, the altarpiece, and the public monument, we do not have a clear sense of the convention that we might speak of as bedroom art. Its history has never been written. We reasonably surmise that Lucretia on a *spalliera* or *cassone* panel presumably for a bedroom stands for the bride's chastity, that the image of Venus on a

panel of this kind alludes to the pleasures of the nuptial couch. But what of the story of Joseph in Borgherini's bedroom?

Joseph was traditionally seen as the type of Christ. Like Christ, Joseph was the special focus of his father's love; like Christ, he was betrayed by his brethren; like Christ, he was reconciled to his brethren and finally exalted. This Christological significance of Joseph in the Borgherini cycle has been demonstrated from the presence among these works of Granacci's *Crucifixion*. It has been reasonably suggested that the explicit image in this cycle of the savior, of the "Salvatore," is an emblematic reference to the name of Margherita's father-in-law Salvi, who commissioned the decorations. Such references to names, as we have seen, are not uncommon, and we might note in support of this hypothesis that in the same period Fra Bartolommeo painted an emblematic *Cristo Salvatore* for Salvador Billi, "alluding to his name," as Vasari says. In the Borgherini cycle the theme of salvation is keyed to the name of the patron Salvi.

Whereas many of the decorations for bedrooms were made for the walls of these rooms or for furniture in proximity to the bed, the decorations by Pontormo and his associates were made either for the bed itself or to be placed in immediate relation to it. This fact, we shall presently see, has a bearing on the significance of their subject for Borgherini. Pontormo's panel, in particular, and Vasari's inaccurate description of its subject are a key to our understanding of this significance.

In the left foreground of this panel Pontormo represented Joseph presenting Jacob to the Pharaoh, but Vasari says that this passage shows Joseph receiving his father Jacob and all his brothers, the sons of Jacob. He thus emphasizes the relations of father and sons in the panel. Vasari does not go on to describe the other two incidents in the painting, but in the center we see Joseph bringing his sons Menasseh and Ephraim to Jacob, and at the upper right we behold the moment when Jacob gives his blessing to Joseph's sons. The painting is, as Vasari understood, notwithstanding his error, primarily about fathers and sons. In other words, the painting is not only about biblical patriarchs but about the continuity of the family line, from father to son. What more fitting subject for a bed and a bedroom, the place where the family was perpetuated from generation to generation, where the continuity of the family was ensured! How noble it was of

the Borgherini family to dignify itself and its own lineage by associating itself with the house of Jacob, "Domus Jacob."

Fathers and Sons

Vasari's mistaken identification of Pharaoh as Joseph, as we observed, is based on his correct understanding that the painting is primarily about fathers and sons, since it represents Jacob and his sons and Joseph and his sons. For Vasari, as for all Florentines, this subject is part of the larger theme of family history. The history of the family, whether of major Florentine houses or of the families of artists, lies at the heart of the *Lives*, and this aspect of Vasari's book is implicit in his description of a curious detail in Pontormo's picture. First Vasari's theme, then the detail.

In Vasari's view of artistic community, the ideal relation of artists to each other is a loving one, of paternal largesse, filial devotion, and fraternal love. In one case, the lives of the Bellini—Iacopo the father, Gentile and Giovanni the sons—Vasari develops his theme by saying that both brothers held their father in "reverenza" and that they were dedicated to each other. Thus, when Gentile returned from Constantinople, Giovanni received him with joy; when Gentile died, Giovanni buried him with fraternal devotion. Giovanni, Vasari pretends, also introduced into Venice the practice of painting portraits of the city's forefathers. Vasari's lives of the Bellini is an idealized, exemplary fiction, which celebrates a loving son, Giovanni, devoted to his brother and father. He is, we might say, a modern Joseph. Vasari expands upon this idea of the artist's family by saying that Iacopo Bellini named his son Gentile after Gentile da Fabriano, who had treated him as a son, and he develops the notion of the metaphorical family of art further by saying that Raphael treated Penni and Giulio Romano like sons, that Bronzino and his disciple Allori treated each other like father and son in their mutual love. This typology of the family of art brings us back to Pontormo's painting and to the curious detail to which I have alluded. Here, Vasari pretends, the painter depicted his disciple Bronzino as a boy. Art historians, who have tried

to date the painting exactly by guessing how old Bronzino is in the painting, have missed the point of Vasari's fiction.

In the life of Bronzino, Vasari writes that the painter was like a son to Pontormo. By pretending that he is present in Pontormo's painting of Jacob and Joseph, he is playing on the fact that the paternal painter's own name is Jacob (Iacopo). Just as Jacob begat Joseph, who begat Menasseh and Ephraim, so Pontormo, a modern Jacob or patriarch among painters, begat Bronzino, who (we saw) begat Allori. Vasari thus writes about the family of art, celebrating its perpetuity.

Margherita's Oration

Speaking of fathers and sons, we are describing the context in which emerges one of the great women or heroines not only of Vasari's book but of all Renaissance literature. Margherita Acciaiuoli distinguishes herself in the aforesaid speech to Giovanbattista della Palla, who tries to buy from her the bedroom decorations, including the Pontormo painting, in order to make a gift of them, along with other works, in the name of the Signoria, to the king of France. Her oration is so vivid, so impassioned, and so graphic in its denunciation of Della Palla that it deserves to be quoted in full, along with Vasari's concluding commentary on it:

> Well then, she said, you dare, Giovanbattista, most vile rag-picker, little two-bit merchant, to confiscate the decorations from the chambers of noblemen of this city and to despoil the city of her richest and most honored treasures—as you have already dared and continue to—in order to embellish with them countries of foreigners, our enemies. I do not marvel only at you, base plebeian man and enemy of your "patria," but at the magistrates of this city who aid you in this abominable wickedness. This bed, which you want for your private interest and greed for money—although you cloak your malevolence in false piety—this is the bed of my nuptials in honor of which my father-in-law Salvi made all this magnificent and regal decoration, which I revere in memory of him and for the love of my husband, and which I intend to defend with my very blood and

life. Out of the house with you and your brigands, Giovanbattista, and go tell those who ordered you to take these things from their proper places that I am a woman who will not tolerate the removal of anything from here; and if they who believe in you, vile creature of no account, want to make presents to the king of France, let them do so by despoiling their own houses of decorations and beds from their own chambers; and if you are so bold as to come into this house ever again on such an errand, I will make you pay greatly and teach you what respect should be paid by your kind to the houses of noblemen. Thus spoke Madonna Margherita, wife of Pierfrancesco Borgherini and daughter of Roberto Acciaiuoli, a most noble and prudent citizen. A woman of great valor and a worthy daughter of her noble father, she spoke with such noble ardor and eloquence that she was the reason that these jewels are still preserved in their house.

Although Margherita's speech is well known to Pontormo's scholars, sometimes even partially quoted by them, they pass by its full significance. Of Vasari's own invention, Margherita's speech remains uninterpreted—accepted at face value, as if true, although it is surely a fiction, but a fiction pointing toward hidden truth. If we probe her speech, however, we find that it tells us a great deal about Pontormo's painting, about Vasari himself, and about how Vasari responded to the work in particular circumstances. Vasari's fictitious oration suggests that the significance attributed to works of art in the Renaissance can sometimes be more subtle and complex than we had supposed.

Vasari's Wives

In the defense of her bedroom during the absence of her husband, Margherita is like the fictitious wife of Cola dell'Amatrice, as Vasari portrays her. They are both of the same noble type in their virtue. Cola's wife is, Vasari says, of an honorable family and is noble of spirit. Pursued, along with her husband, by soldiers, she decides that she can save her honor only by throwing herself off a cliff. When she jumps, the

soldiers see that she is mortally wounded, dashed to pieces, and they depart without harming her husband. By committing suicide she both preserves her honor and saves her husband. Whereas Margherita's virtue resides in her words, that of Cola's wife is expressed through her deeds.

This noble type is, however, overshadowed in Vasari's *Lives* by wives who are treacherous or difficult. The most famous example, given new life by Robert Browning, was the wife of Vasari's teacher, Andrea del Sarto, the imperious Lucrezia, who gave her husband so much trouble. In a variation on this fiction, Vasari observes that Sarto's colleague Franciabigio never took a wife, saying with a trite proverb: "He who has a wife has pains and sorrows." Raphael, Vasari also emphasizes, resisted the pressure of Cardinal Bibbiena, who wanted him to marry the cardinal's niece, or so the story goes, and Taddeo Zuccaro, whom Vasari paints as a new Raphael, resisted the pressures from friends to marry because he did not want the "thousand annoying cares and aggravations of having a wife." In a more comic vein, we recall, Paolo Uccello was so devoted to his art, to his true mistress, that he would not come to bed when called by his wife.

In a variation on this theme, Vasari has Bugiardini say that his painting is more beautiful than any woman. This remark also brings to mind Michelangelo's acerbic response to the remark that it was a pity he never married—"I have wife enough," by which he meant of course his art. Vasari's hostile view of wives is crystallized in the fresco that he says he painted in his house in Arezzo of a wife, painted, he claims, as a sort of joke, "quasi burlando." The fresco shows a wife, who has a rake in her hand, which indicates, he explains, all the money she has raked away from her father. She holds in her other hand, as she enters her husband's house, a lighted torch, showing that wherever she goes she carries fire, which consumes and destroys everything.

The noble Margherita and her sister in virtue, the wife of Cola, are set off against imperious and greedy wives who cause trouble. Vasari's attitude toward wives is one of extreme ambivalence, an ambivalence born of a society in which women, although deemed necessary and thus sometimes extolled or idealized, were also feared and disparaged for the difficulties they were perceived to have created. Although Margherita is the heroine of Vasari's tale of Pontormo's painting, she is defined primarily by her relations to her husband, to her father, and to her father-in-law. She is a creature of men. Her ambiguous status

and Vasari's ambivalent attitude toward wives recalls that in Alberti's *Della Famiglia*. Although Alberti celebrated the skills of women in running the household, he emphasized the role of their husbands in instructing them, in training them, in establishing their place in the world. Like the Florentine wives of Alberti, Margherita is the creation of a patriarchy.

Penelope and Lucretia

In the life of Properzia de' Rossi, Vasari presents a catalogue of great women from antiquity to the present—warriors, poets, and artists— Camilla, Hippolyta, Sappho, Veronica Gambara, Laura Battiferri, and Properzia herself. Clearly Margherita belongs to such a list of exalted women, but her significance cuts far deeper. Not only are her values shaped by men, in Vasari's view, but she is formed in the image and likeness of a man, the very subject of the panel by Pontormo that she protects from Della Palla.

When Vasari says that she resisted the sale of the paintings in her bedroom to one who would sell them to the king of France, he is playing on the story of Joseph, who was sold into bondage. Della Palla would have the "patria" sell its "Joseph," as Joseph's brethren had sold him. Margherita's protection of her marriage bed, whatever else it suggests, is set in the context of the story of Joseph in still another respect. Joseph resisted the temptations of Potiphar's wife, and Margherita's defense of her bed is worthy of Joseph. Like Joseph, she does not defile a bed in a sinful act.

Although Margherita does not resort to arms, she expresses a fury and valor in words worthy of a heroic warrior. In this respect she is a modern counterpart of biblical heroines in arms, of Deborah or Judith. It is more than force, however, that she embodies. When she threatens to give up her life if necessary to protect the bed of her husband and her fathers, she is far more explicitly a modern Lucretia. Echoing Livy, Vasari has her play the Lucretia to Della Palla's Tarquin. In her long speech, she is especially like Lucretia, who similarly invoked the honor of her father and husband in her final words. Margherita's speech is not only classical in symbolic associations but in its form. As a fictitious speech, it is related to the convention of invented orations in various Renaissance histories, for example, Ma-

chiavelli's *History of Florence.* This tradition can be traced back through Livy to ancient Greece, notably to Thucydides. When we consider that Margherita is not simply protecting her bed but also defending a treasure of her city, we see that her oration takes its place in the tradition of great civic rhetoric that descends from Pericles' funeral oration to the Athenians.

If in her ardor and valor Margherita is a modern Lucretia willing to spill her own blood to protect her marriage bed, she is no less a modern Penelope in her defense of that bed. Like Penelope, she is a woman, Vasari says, of "ingegno." During the absence of Odysseus, Penelope had resisted her iniquitous suitors, protecting the bed of her nuptials with extreme cunning. Her bed, the very type of marriage beds, was decorated with inlays of gold, silver, and ivory. So, too, while Pierfrancesco Borgherini was away, the modern Penelope, Margherita, protected her marriage bed from one who would defile it. In the sheer magnificence of its decorations Margherita's bed, as described by Vasari, calls to mind the most artful of classical beds symbolic of marital fidelity. We know that Homer was, in fact, in Vasari's mind when he wrote the life of Pontormo because at the end of the biography of the artist he remarks on the painter's final decline by saying proverbially that "even the good Homer nods sometimes."

The panel paintings and wall paintings that adorned bedrooms in the Renaissance often illustrated classical myths or historical subjects, celebrating the virtue of the bride—whether Pinturicchio's fresco of Penelope at her loom or Botticelli's panel of Lucretia. It is as if Vasari, when he makes Margherita into a modern Penelope or Lucretia delivering her animated speech, reanimated the classical sources to which he alludes. Revivifying these classical stories in a modern version in a contemporary setting, Vasari, like the classicizing artists of his day, brings antiquity back to life. Reading Vasari, we can almost hear the "visible speech" of Renaissance paintings depicting exemplary classical subjects and their virtues.

A Dantesque Perspective

Not only is Margherita a dutiful daughter and noble wife, she is also a great citizen, for she defends her city against a villainous despoiler of

its treasures. She thus takes her place along with Farinata degli Uberti among the most noble of Florentine defenders. Even when Dante necessarily puts Farinata in hell for his heretical views, he reveals his respect for this great hero who defended his city from destruction, who was therefore immortalized in Villani's history of Florence and later in Castagno's frescoes of illustrious men and women.

Whereas Margherita is a heroine, Della Palla is most vicious. More than greedy, he is a traitor to his country, as Margherita tells him; he deserves to be placed among the fraudulent at the bottom of hell. Just as Vasari made Castagno into such a diabolical type, he does the same with Della Palla, implicitly comparing him in his "false piety" to the treacherous Ugolino, who was also a traitor to his city. Della Palla is to Margherita what Ugolino is to Farinata.

When Vasari compares Margherita to Joseph (who is a type of Christ), to Penelope, and to Lucretia in order to celebrate the triumph of virtue over vice, of honor over greed and fraudulence, he follows a conventional literary practice of extolling virtue. In *Purgatorio* X, for example, Dante envisions three giant reliefs that show the Annunciation to the Virgin, David entering into Jerusalem, and the legendary scene of Trajan's justice, all three of which exemplify the virtues of humility and justice. Just as Dante turns to classical and biblical subjects here, linking them in his visual hymn to virtue, so does Vasari in his exemplary tale of Margherita's nobility. But whereas Dante links three separate embodiments of virtue, Vasari combines such exemplary figures in a single personage. We fail to understand the richness of Margherita's speech if we neglect its full typological implications, linking her to heroes and heroines, biblical, classical, and modern, if we do not see how Vasari so artfully conflates them into a single figure.

Of Patriarchs and Patricians

Vasari's Margherita Acciaiuoli is, we have seen, the creature of a patriarchal society, for she expresses the values of the Florentine patriciate. A daughter who shows reverence to her husband, father, and father-in-law, she is also a defender of her fatherland or what she

calls her "patria." Indeed, we do not recognize the full significance of her speech if we ignore its deep civic or political meaning. The paintings made for Pontormo's patriciate patrons or "padroni" are part of both the family patrimony, which Margherita preserves, and the patrimony of her Florentine "patria," which she defends.

When the Borgherini celebrated themselves through the story of Joseph, they identified themselves as patricians with the ancient patriarchs of the Hebrew Bible, with the "Domus Jacob." In the story of Jacob and Joseph, Jacob gave his paternal blessing to his sons, and they were, the Bible says, the twelve tribes of Israel. In other words, the story of a great patriarch and his family was the story of a great nation. In Vasari's biblically charged fiction, we see how a family history of the patriciate is linked with the "patria." His tale, although a fiction, is true to the values of Florentine society, which celebrated the place of the family in civic life. In Vasari's account, Salvi blessed the marriage of his son Pierfrancesco by commissioning a lavishly decorated bed, which symbolized the perpetuation of the family line. A modern patriarch, Salvi no doubt hoped for the fruitful propagation of his family line, of his modern house of Jacob. Margherita's defense of her father and father-in-law, worthy of Joseph's own filial piety, is the celebration both of her noble family and of her "patria"—for the story of her patrician family and of the "patria," as in the Bible, were one and the same.

Joseph and Pharaoh

Vasari's tale of Pontormo's panel is not only suggestive of its original meaning, both religious and civic, but it also tells us something of the world that Vasari inhabited half a century after the Borgherini bed was made. In the life of Pontormo's disciple Bronzino, Vasari says that both artists, along with Salviati, made designs for tapestries illustrating the story of Joseph. This decoration, to be placed in the Sala del Consiglio de' Duegento, celebrated Duke Cosimo de' Medici as a modern Joseph, who personified all the biblical hero's virtues. It is clearly with this view of Joseph as the type of Medicean prince that Vasari recalls Pontormo's earlier picture, for he mistakenly identifies the figure of Pharaoh there as Joseph, "nearly king and prince." Vasari

may well recall the biblical description of Joseph as ruler over Egypt under Pharaoh, but he goes a step further (inspired by the Josephine ruler Cosimo) when he sees Joseph as the Pharaoh himself.

Vasari could easily make this mistake of identity in describing Pontormo's painting, since now in Duke Cosimo's Florence Joseph stood for the ruler, just as David, once a symbol of the Republic, had become a figure of Cosimo's kingly rule. In other words, Vasari refashioned Pontormo's Joseph into Pharaoh, because Joseph was the type of a virtuous prince or ruler, like Cosimo. We might say that Vasari reinterpreted the Borgherini panel through the meaning that inheres in Pontormo's subsequent illustrations of the story of Joseph for the Medici thirty years later. When Vasari calls the Borgherini decorations "regal," this is not because the Borgherini had explicitly princely aspirations, but because he wrote for a Medici ruler, who identified himself with Joseph.

We should not dismiss Vasari's description of Pharaoh as Joseph, still followed by some in the modern scholarship, as a mere "error" or "mistaken identity," since Vasari's identification of the figure is in itself a valuable indication of how during the Renaissance meaning was transformed and given new significance in light of changing political circumstances. Vasari's variation on Pontormo's originally intended subject is itself a part of Renaissance history—a valuable part of the history of responses to art. It is an example of the ever-changing significance of a work of art, which retains something of its original meaning at the same time that it is, in the beholder's own experience, transformed into something else, a "nuova cosa."

The Siege of Florence

Pontormo helped decorate Borgherini's bed sometime after the wedding in 1515. The moment of this decoration is a significant one in Florentine history, for it is the period of the Medici return to Florence from exile. Although Vasari does not connect the painting of Joseph to events contemporary with its execution, we should note that, like Dante, like Michelangelo, like the Medici themselves, Vasari conceived of the theme of exile in terms of the Exodus of the ancient Jews. This biblical context should not be forgotten here, especially

since the Borgherini panels illustrating the history of Joseph, who returned from exile after he was sold into bondage, came from the moment of such a Medici return. In 1515, the year of the Borgherini wedding, Pope Leo X triumphantly entered into Florence, symbolizing thereby the return of the Medici from exile. This was a great moment in both Medicean and Florentine history, and Vasari later illustrated Leo's triumphant entry prominently in the Palazzo Vecchio. Two years earlier, during the carnival of 1513, Pontormo had been commissioned to celebrate the Medici restoration by making decorations of classical cars or chariots symbolizing their triumph. The image of Joseph upon such a car at the lower right of Pontormo's Borgherini panel has been reasonably linked to Pontormo's previous decorations. The connection between the story of Joseph and the return of the Medici may, therefore, have already been in Pontormo's mind before Vasari brought them together in his own imagination.

After their restoration to power, the Medici dominated Florentine political life until 1527, when they were again driven into exile and the Republic was restored. This moment from 1527 to 1530 was the period that culminated the great siege or what Vasari calls "assedio," which corresponds in its horrors and devastations to the contemporary Sack of Rome. This moment is crucial to our understanding of Pontormo's panel of Joseph in Vasari's imagination, for it is the very moment of Margherita's imaginary oration in defense of the painting.

One cannot underestimate the horrors of the great siege. Vasari will not let us. In life after life, he records all its devastations. As an apocalyptic catastrophe, it takes on a significance in the *Lives* comparable to that of its description at the end of Guicciardini's *History of Italy*. In biography after biography—in the lives of Iacopo di Casentino, Lippo Fiorentino, Lorenzo Monaco, Andrea del Castagno, Pietro Perugino, Domenico Ghirlandaio, and Michelozzo, to cite but a few examples—Vasari registers the trauma of this event: "the plagues of that year," the "ruins of the siege." He is always quick to list the various works destroyed during the "sack" of Florence by invading forces, especially the splendid lamps at Santissima Annunziata, not to mention the monasteries, hospitals, and other buildings outside the city walls destroyed or badly damaged, including San Salvi. Only the fact that the captain of the invading forces was so impressed by Sarto's *Last Supper* at this church made possible its preservation. One could publish a catalogue raisonné of all the works listed by Vasari that

perished during the siege, and it would be impressive in its length. The citizens of Florence fought heroically to defend their city, and Michelangelo, Vasari emphasizes, was called upon to build important fortifications as part of that defense. This, then, is the context in which Vasari sees Margherita Acciaiuoli bravely defending the city's patrimony against the traitorous Della Palla, who is, like the invading forces, despoiling the city during the Medici exile.

Vasari's passion and sorrow, rendered through Margherita's speech, is highly personal and deeply felt, since he was in Florence during the siege. In light of his own activity, her speech takes on autobiographical coloring. In the life of his friend Salviati, he says that in 1527, when the Medici were exiled, a bench was thrown from the Palazzo della Signoria during a battle, which fell on the arm of Michelangelo's *David*, breaking it in three pieces. He goes on to say that he and Salviati, still boys, went out into the piazza in the midst of soldiers and, not "thinking of any danger," picked up the pieces of marble and brought them to the house of Salviati's father. With great rhetorical flourish, Vasari is commenting on his own bravery during the siege, on his own defense of a great work of art that is part of the city's patrimony, like those from Borgherini's bedroom protected by Margherita. He also takes his place along with his hero Michelangelo, who, through his fortifications, similarly defended the city.

Here, as elsewhere in the *Lives*, Vasari speaks of himself as "Giorgio," giving an objective or impersonal tone to his report, whereas he was in fact deeply involved in the events he describes. Even if his account of Margherita's speech has some basis in reality, it is, as I have insisted, primarily a fiction, but this fiction expresses Vasari's own feelings when he himself defended Florence from the brutal attack of 1527 by protecting her artistic patrimony. Seen in the context of Vasari's own life, Margherita's speech is a clue to the deep, often not disguised, autobiographical character of the *Lives*, which can be read as the story of his own life.

The Book of the Artist

Before probing more deeply into the *Lives* as an autobiographical work, we should see how Vasari gives definition in it to an ideal artist.

He does this by comparing the history of art to the ages of man. The implication of this famous comparison is that the history of art is the life or biography of an imaginary or ideal artist, who transcends individual artists. Vasari speaks of the first period of his history, the period of Giotto and his followers, as the childhood or "fanciullezza" of art, suggesting further that the next period, that of Brunelleschi, Donatello, and Masaccio, is its youth. The final period, that of the "terza maniera" of Leonardo, Michelangelo, and Raphael and their followers, represents the maturity of art. It is sometimes said, however, that this extended metaphor comparing history to biography is problematic, since the artist grows old and decrepit, and then what? For Vasari this is not a problem. We fail to understand his concept of biography if we do not see its deep theological meaning. Just as Michelangelo, who embodies this final period, speaks, as he grows old, of his spiritual "rebirth," Vasari envisions such rebirth in the life of his ideal artist, who has the capacity for spiritual and artistic renewal.

The life of this ideal artist as defined by Vasari is thus one like any individual life—of birth, childhood, maturity, decrepitude, and rebirth. It is a life of an ideal artist, whose childhood is embodied in Giotto, its youth in Masaccio, its maturity and old age in Michelangelo, before his "rebirth" in the work of Michelangelo's followers in Vasari's Accademia del Disegno. Something of Vasari's original theological language persists in the vocabulary of modern art historians, who speak of Vasari's students as reformers of Florentine art.

In thinking of Vasari's biographies as part of the biography of a single, ideal artist, we recognize the relation of his book to other literary genres. Vasari's book can be compared especially to Castiglione's *Book of the Courtier*. It is a kind of "Libro del Artefice," a Book of the Artist like the *Libro del Cortegiano*. Vasari's specific uses of Castiglione are often remarked, for example, his notion of grace, which informs his biography of Castiglione's friend Raphael, who embodies many of the virtues extolled by Castiglione in the *Book of the Courtier*. In his life of Raphael's student, Giulio Romano, Vasari speaks of Castiglione as a "formator" of the perfect courtier. In like fashion, Vasari is a "formator" of the perfect or ideal artist, who is gradually given shape through his book. This ideal artist, who is born in the thirteenth century and who reaches maturity in the sixteenth century, is therefore a metaphorical giant, striding across the ages. As a colossus, Vasari's perfect artist is like the ideal, colossal works of his

hero Michelangelo, endowed with all their grace and invested with all their perfection.

Vasari's ideal artist also can be compared to Rabelais's giants, perfected a short time earlier. Both Vasari's metaphorical giant, embodied in its final form in Michelangelo, and Gargantua descend from Castiglione. Rabelais's Gargantua is a caricature of Castiglione's courtier. The caricature is made by gigantism, that is, making the ideal perfection ridiculous by inflating it into enormousness. Gargantua's education, dress, speech, and manners all parody the perfect courtier. Vasari's compound, giant artist is comparably laughable in his pranks, jests, wordplay, and witticisms. Like *Gargantua*, Vasari's biographies are the chapters in a "biographie romancée" of a giant. Like Gargantua, Vasari's colossal, compound artist is a protean figure of extreme artifice, vulgarity, physical appetites, and crudity: the refinement and amours of Giorgione, the vulgarity of Niccolò Grosso, the heavy drinking of Sebastiano del Piombo. Vasari's giant artist strides through the ages toward the Thélème-like paradise of Duke Cosimo's Florence, which, like Thélème itself, is envisioned in the image and likeness of Castiglione's Urbino.

Vasari and "Vasari"

Reading Vasari's book as a series of biographies that become the idealized biography of a giant—epitomized by Michelangelo, himself a creator of giants—is not inconsistent with our reading of the entire book as autobiography. As autobiography, the *Lives* occupy an important place in the history of autobiography.

Although Vasari is never mentioned in Burckhardt's *The Civilization of the Renaissance in Italy,* he is essentially present in the famous second part of the book on the "development of the individual," where Burckhardt writes about biography and autobiography, on the theme of glory and fame, on the cult of famous men, on birthplaces and graves. Vasari's book is the epitome of such biography; its theme is the fame and glory of artists; it is filled with descriptions of birthplaces, funerals, and epitaphs. In Burckhardt's view, Dante is the foundation of the modern view of man. This perspective is not surprising, since Dante makes himself the protagonist of his *Comedy,* and his

Vita Nuova is the basis of the modern lyrical tradition. Michelangelo would later make himself into a comparable Dantesque pilgrim and would write confessional poetry in the tradition of Dante. Writing the *Lives*, Vasari also becomes a Dantesque pilgrim who journeys through the "Divine Comedy" of art from the period of Giotto through the time of Michelangelo. By this I mean that he does not merely describe the art and artists of the past, but that his journey takes him from place to place, from work to work, from artist to artist. In almost all of his biographies of others, he speaks of himself as a character or subject, as either "Giorgio" or "Giorgio Vasari"—as when, for example, in the life of Salviati, he speaks of his preservation of the broken arm of Michelangelo's *David*. "Giorgio Vasari" is very much a character in his own book, just as "Dante" is in the *Comedy*. If Michelangelo is the supreme Dantesque hero of Vasari's "Comedy," this fact should not obscure our understanding that, in a perhaps less obvious way, "Vasari" is a prominent character in his own *Lives*—that his book can be read as autobiography.

Petrarch and Arezzo

In Burckhardt's scheme, Petrarch, with his cult of glory, is the next important figure after Dante in the history of Renaissance biography. More than a biographer, Petrarch is an autobiographical writer—both in his letters and, imaginatively, in his *Canzoniere*, which, exploring his love for Laura, is a deeply revealing document of the writer's psychic life. Petrarch is a particularly important figure for Vasari because he came from Vasari's native Arezzo. It is significant that when Vasari wrote the biography of Michelangelo he emphasized Michelangelo's remark on his being born near Arezzo, on the purity of the air of Arezzo—a feature of Arezzo that Vasari comments on in his own life at the end of the *Lives*. Like Petrarch, the Petrarchan Michelangelo came from Arezzo or, at least, its environs, and Vasari is sure to mark this fact, since, like Michelangelo, he too comes from the city of Petrarch.

Petrarch, as we have already observed, is always on Vasari's mind. Speaking of Leonardo, he quotes from the *Trionfi*, which alludes to the triumph of Leonardo's art, playing on his name Vinci (related to

"vincere," to triumph). One of the various reasons Vasari dwells on the triumphant chariots designed by Pontormo and Piero de Cosimo, described in vivid detail, is that these "carri" have their immediate literary antecedent in Petrarch's authoritative *Trionfi*. Vasari is also sure to tell us that Pontormo, who painted Petrarchan "Trionfi," came from Ancisa, which is famous because it is the place in which Petrarch's ancestors had their origins. When Vasari writes of Arezzo, he not only celebrates his own birthplace but he magnifies himself by virtue of his association with the birthplace of Petrarch. Like Petrarch and Michelangelo, Vasari came to be associated with Florence, but, as we shall see presently, Arezzo figures prominently in the "autobiography" of the *Lives*, because as the city of Petrarch, it reinforces Vasari's self-identification with Petrarch. In short, Vasari shares Petrarch's glory. Like Petrarch, he is not only interested in the "glory" of others, in the "glory" of the ancients, but he is interested in the fame of his own name, immortalized in the autobiography of the *Lives* and given magnitude by virtue of its connection with Petrarch's life. If Petrarch had assured the glory of Simone Martini, as Vasari says, Vasari sees to it that Petrarch, Petrarch the Aretine, contributes to Vasari's own.

Pietro and Giorgio Aretino

Burckhardt concluded his discussion of the "development of the individual" by briefly discussing the work of Vasari's friend Pietro Aretino. For Burckhardt, Aretino's uses of self-publicity are part of the story of how writers achieved fame and glory. Even at this late date Aretino's literary importance is not fully understood, because he was the author of pornographic poetry and because his inflated view of himself is distasteful. When Aretino collected and published his letters, beginning in 1537, he followed the example of his compatriot Petrarch, who had made famous collections of his own letters, known as the *Familiari*. To read Aretino's admittedly less important letters is nonetheless like reading Petrarch's, for in both cases it is to read the chapters of an implied autobiography, one in which the authors seek to establish their own fame. Aretino achieves his glory by association with Clement VII, Charles V, and Henry VIII, and he discourses in cameo-essays on love, food, the beauty of nature, the virtues of adversity,

speaking further of his dreams, travels, life in Venice, of an ill-fated love affair, in short, of episodes in his notorious life. Like Petrarch's letters, Aretino's are frequently "essays" and are related, if less intro- spectively, to Montaigne's invention of that literary form a short time later. I invoke Montaigne here because the tradition of autobiographi- cal writing from Dante and Petrarch to Aretino, to which Vasari be- longs, is the tradition epitomized in Montaigne's writings about him- self in the *Essais*.

When Aretino says that horses, a canal in Venice, and girls are all named after him, that he is the secretary of the world, he projects an image of himself as a giant. We laugh at his pomposity, as we laugh at that of Cellini aggrandizing himself as a colossus in his autobiography. Portraying himself as a laughable giant, Aretino emerges as an Italian Gargantua, forever eating at banquets, imbibing splendid wines, en- joying the pleasures of the couch. His letters are his *Vita*, and their publication assured the fame of his life.

Vasari, it has often been observed, learned to write about art from his friend Aretino, and, we might add, it is likely that he also learned to celebrate himself, his own glory, from Aretino's example. No mat- ter that his *Lives* are not letters as such, for like Aretino's letters they are often both like essays and highly personal. At one moment Vasari discourses on such general topics as virtue and fortune, at others he writes specifically about his family tomb, his encounters with great monarchs and popes, his travels, his conversations with other artists, about what he saw, heard, and thought. Pietro Aretino is an important link between Petrarch of Arezzo and Giorgio Vasari Aretino. Like Aretino's letters, Vasari's *Lives* constitutes one of the major autobio- graphical documents of Renaissance literature. No matter that Burck- hardt never mentions Vasari, for he is ever-present in this history of autobiographical writing, even though never named. His book is part of the heritage of the little town of Arezzo, which contributed so much to the mainstream of modern autobiography.

The "Real Life" of the *Lives*

Vasari, clearly recognizing the danger of his book becoming a mere list of works of art, insisted somewhat defensively in the "proemio" to

the *Lives* that he intended to present more than a "catalogue." When we read in his book, however, we see that he did not fully succeed in this respect because there are times when his biographies of artists do indeed degenerate into such lists. Even so, we should bear in mind that these lists are more than a catalogue. His descriptions of works of art are for the most part the result of direct experience. We often find Vasari commenting, as I have noted, in the first person, telling us what he saw, when he saw it, and what he felt in experiencing a particular work. In other words, his descriptions are part of his life, of his autobiography. Julius von Schlosser once remarked that Vasari's "autobiography," the "vita" that he attached at the end of the *Lives*, is "colorless" and "superficial," as it is—as if it had been added, tacked on to the *Lives*, hastily collected from his notes or "ricordi," as an afterthought. Vasari's autobiography is far more interesting, however, as we find it reflected in the totality of the *Lives*.

Vasari often makes it clear that a description of a work of art is based on a particular experience in his life. Speaking of Cimabue's work in Assisi, for example, he says that "in 1563 I saw it again," adding that "in my judgment" it must have stupefied the world. In the life of Giotto, he says that "not many years ago, finding myself in the hermitage at Camaldoli, where I did many works for the holy fathers, I saw in a cell, brought there by the Reverend Antonio da Pisa, the General of the Congregation, a little Crucifix on a field of gold attributed to Giotto, which is very beautiful." On occasion Vasari will report something that Michelangelo told him, a comment on a particular artist or his work, for example, Michelangelo's praise of a panel by Giotto. When we recall that Vasari promised to publish a dialogue between himself and Michelangelo on art (which never appeared), we might conclude that the various comments made by Michelangelo to Vasari throughout the *Lives*—judgments, for example, on Masaccio, Gentile da Fabriano, Filippo Lippi, Baccio d'Agnolo, Perugino—are part of that "lost" dialogue. As such, these fragments of conversations are part of Vasari's own life.

Speaking of the work of Stefano Fiorentino, Vasari interjects, "io stupisco," I marvel, a conventional term of praise, to be sure, but no less personal for all its conventionality. If Vasari's descriptions of works of art in general are necessarily conventionalized, it is nonetheless still true that his descriptions indicate the way he saw these works and how he experienced them. When Vasari says that a work is "mar-

velous," we can read this description to mean, "I marvel" at it—that it fills me, Giorgio Vasari, with wonder, as it will you, my reader. When we read Vasari, we need to remember that most of those lists of works are lists that he compiled at different moments in his life, on various, particular trips, that these descriptions of works are as personal as they are conventional, that Vasari is writing as an individual, whose specific responses are reflections of particular experiences, whether in Siena, Venice, Rome, or Florence, that they are part of his life, the underlying "real life" of the *Lives*.

Vasari's Family Mausoleum

In biography the subject's life is marked usually by the place where he or she was born and raised. We are acutely aware of this fact in modern autobiographical writing, in both fiction and nonfiction, in the writings of Wordsworth, Proust, and Joyce. This relation of person to place is no less true in the Renaissance, at the dawn of the modern period. It is particularly true of Vasari, who writes a great deal about Arezzo, disproportionately so, given its comparatively minor place in the history of art. This attention to his own town is usually seen as a reflection of Vasari's patriotism, his love of "patria," and rightly so. It also can be seen, however, as a reflection of Vasari's own "vita" or autobiography, especially since what Vasari describes in Arezzo are monuments to which he proudly contributed.

Arnolfo, Marchionne, Gaddo Gaddi, Margaritone, Agnolo and Agostino Sanese, Pietro Lorenzetti, Buffalmacco, Giottino, Berna da Siena, Iacopo di Casentino, Spinello Aretino, Lippo Fiorentino, Lorenzo Monaco—these are among the artists who, during the thirteenth and fourteenth centuries, built and decorated Vasari's hometown. Vasari pretends that Arnolfo, the famous master-builder of Florence, was responsible for the Palazzo de' Signori of Arezzo, and he often attaches famous names to minor decorations purely for the greater glory of his native city. Over and over Vasari also speaks of works made for the major buildings of Arezzo, especially the Pieve or parish church. Telling us that Marchionne built the Pieve, Vasari brings the building into the present, in a sense, when he describes all the "strange and extrava-

gant inventions" of its column, its "capricious variety." It is as if Vasari were celebrating the fantasy of the grotesque style of his own day, even though the work of which he speaks is done in the "barbarian manner." Vasari evokes the ideal of the classical grotesque, for example, that of the famous Chimera, the fabulous and fantastical beast discovered in Arezzo in the sixteenth century, as he tells us elsewhere—a work that found its way prominently into the collection of Vasari's esteemed patron, Duke Cosimo de' Medici. No matter that the Pieve is still Romanesque. Vasari links its fantasy of form in imagination with the modern style of his own day, that is, "alla grottesca."

Vasari says further that Pietro and Paolo Aretino also worked in the Pieve, that Giotto made a Crucifix there, that later Baccio da Montelupo made a Crucifix for the church and that Fra Bartolommeo made a head of Christ for this venerable place. Of all these decorations, the most important was that begun by Pietro Lorenzetti, who made the high altarpiece, a work that Vasari describes in great detail: a Madonna with saints, truly beautiful figures, as he says, made with "bonissima maniera." Why is this work so important? Because it stood on the high altar that Vasari himself restored. "I remade it completely," he brags, "at my own expense and with my own hand." Vasari says that he did so because of the "Christian piety and love I have for this venerable church . . . and because here are the remains of my ancestors, and I have restored it so that one can say that I have brought it back to life from death." Made "in honor of God," the restoration was done with "marble, porphyry, and other stones"—a truly magnificent work that demonstrates Vasari's skill, his religious fervor, and his filial piety.

This is not the last time Vasari mentions his work in the Pieve, for in the life of his ancestor Lazzaro, he discusses it along with the family sepulcher made there by "Giorgio Vasari the last, the writer of the present story," and, in his "vita" at the end of the Lives, he refers to it once again. Speaking of the Pieve over and over again, Vasari traces its history from its inception to its crowning glory, the work of Vasari himself. The Pieve becomes important in the Lives as a place where Vasari demonstrates his love of family and commune. It becomes the site of Vasari's family mausoleum, taking its central place in the interrelated history of Arezzo, genealogy of the Vasari family, and life of Vasari himself.

Arezzo Aggrandized

Vasari's devotion to his father, to his fathers, reflected in the family tomb he built in the Pieve, is part of the story he writes throughout the *Lives* of loving sons—whether he is speaking of the Bellini or of the story of Joseph. Vasari suggests this kind of filial piety when he pretends that Giovanni Pisano made a portrait of his father Nicola in Santa Maria della Spina. He also enters directly into the lives of this family when he says that he made the design for the support of an organ in the chapel of the Ubertini in the Vescovado, which had been built originally by Giovanni Pisano. Speaking of the Vescovado, perhaps the greatest building in Arezzo, he writes in detail about its considerable expense, of its religious and historical subjects, including Barbarossa's trip through Arezzo en route to Rome and San Donato, patron saint of the city. By restoring a work in a major family chapel of the Vescovado, he places himself in relation to a "very noble family," as he says, and by working where Giovanno Pisano had labored, his work is associated with that of one of the noble families of art. His work for the Ubertini Chapel, he adds as a matter of fact, is of "extraordinary beauty." What matter that he writes of himself here in the third person? His self-importance is like that of his compatriot Aretino, who exalts himself through his relations with noble houses and famous artists.

In the life of Giottino, Vasari again appears, making another restoration in the Vescovado. He says that Giottino's disciple Giovanni Toscano decorated the chapel there for the wife of Tarlato da Pietra Mala, which contained an Annunciation that Vasari restored. Vasari mentions impersonally that "Giorgio Vasari" carried out this work while still a youth. Paying attention to Vasari's very intervention in the lives of other artists, we come to see more and more how the *Lives* mirrors particular moments in his own life, even though these moments are not presented in chronological order.

Vasari's interventions in the Vescovado are part of a long history, which includes works there by Giotto, Buffalmacco, Taddeo Gaddi, and countless others. One could easily write a guidebook on this building, as on all the major monuments of Arezzo, from the *Lives*. Pride of place in this guidebook would go to the tomb of Bishop Guido Tarlati, Lord and Bishop of Arezzo, commissioned by Piero

Saccone da Pietra Mala. Vasari pretends that Giotto designed this tomb, executed by Agostino and Agnolo Sanese, in order to magnify its glory. He describes the scenes in relief upon the tomb in great detail: the bishop rebuilding the walls of Arezzo, the Aretine sieges of Lucignano, Chiusi, Fronzoli, Rondine, Bucine in Valdarno, Caprese, the Castle of Laterino, and Monte Sansovino, the crowning triumph of the bishop. The tomb contains six square stones, which Vasari compares to the six balls of the Medici arms. The comparison is pointed, because the magnificent tomb in Arrezo, with all its political and military symbolism, belongs to the history of great tombs, culminating in Michelangelo's tombs of the Medici in San Lorenzo and in the mausoleum for the Medici dukes, in the same church, designed by Vasari himself. Vasari sees great moments in the history of Arezzo through his experience in Medicean Florence. Celebrating his native city, its military triumphs, its lord and ruler, he extols it all as an antecedent to the Medici. His description of the glories of his native Arezzo resembles and foretells his similar glorifications of the Medici.

The little town of Arezzo grows in Vasari's vision into a place of great distinction, and he does not miss an opportunity to magnify its importance. We recall his reference to the Aretine Petrarch in the life of Simone Martini, as well as his fictions about the Aretine artists, Spinello Aretino and Parri Spinelli. Portraying these characters in his fiction, Vasari creates vivid and memorable figures worthy of those already invented in Florence by Franco Sacchetti. Vasari embellishes his account of Aretine glory by pretending that Spinello Aretino taught the Florentine painter Bernardo Daddi, a chronological impossibility. Spinello, Vasari claims, worked with Iacopo di Casentino, who came from the region near Arezzo. When in the life of the latter he says that around 1350 Iacopo formed a fraternity of artists, part of a "renaissance" of painting, he is speaking of himself, forming an academy of art, seeking to reform painting two hundred years later. Just as Vasari finds the seeds of great Florentine tombs in his native Arezzo, he locates important antecedents of the future greatness of Florentine art in general in his native city. Vasari's Arezzo, the city of Spinello, Parri, Niccolò Aretino, and Lazzaro Vasari, an ancestor, presages the greatness of Florence—a greatness to which Vasari Aretino himself would contribute.

An Aretine Jest

As the *Lives* unfolds, Vasari continues to aggrandize Arezzo, never failing to mention distinguished citizens, for example, Leonardo Bruni and Carlo Marsuppini, both chancellors of Florence, and of course his friend Pietro Aretino. He uses the life of the shadowy Niccolò Aretino as an opportunity to write about Aretine history, about the time when the sons of Piero Saccone were thrown out of Arezzo by Pietra Mala. He also exploits the life of Parri Spinelli in order to praise the Beato Tommasuolo, whose preaching united the Aretines, and also to praise the famous San Bernardino, who converted the Aretines. He pretends that Parri built the church of Santa Maria delle Grazie, in accordance with a plan of San Bernardino, on the very spot to which the saint led the people of Arezzo. Describing the decorations by Parri and later by Bartolommeo della Gatta and Lappoli, Vasari tells us about the religious and civic life of his native town. He is thus speaking to us about his own experiences and memories.

In the same manner that Vasari made Spinello Aretino and Parri Spinelli so memorable through vivid anecdotes, he makes the otherwise obscure Lorentino di Andrea d'Arezzo Aretino immortal, inventing a charming jest about the painter. Vasari places Lorentino in the history of Arezzo by saying that he painted Tommaso Marzi, Piero Traditi, Donato Rosselli, and Giuliano Nardi, all prominent citizens, in the church of Santa Maria delle Grazie, and that he portrayed Galeotto, Cardinal of Pietra Mala, Bishop Guglielmino degl' Ubertini, and Angelo Albergotti, doctor of law, in the Palazzo de' Priori. Having placed him in this august company, Vasari tells a story about Lorentino, who, by the way, is named after San Laurentino, a patron saint of Arezzo. "Dicesi" (it is said), Vasari begins—a standard device with which he often begins his tall tales.

Once upon a time, in the season before carnival, the sons of Lorentino prayed that he would kill a pig, which was the local custom, but Lorentino had no money to buy the pig. "How will we buy a pig, Daddy, if we have no money," they asked. "Some saint will help us," the painter replied. Time passed and nothing happened, but then a peasant from Pieve a Quarto asked Lorentino to paint an offering to Saint Martin, explaining that although he could not pay with cash, he could offer the painter a pig worth five lire. Lorentino accepted this

payment and the peasant brought him the pig. Vasari concludes his story with wonderful alliteration: "il santo provide il porco a i poveri figliuoli di questo pittore." The saint provided the pig to the poor children of the painter.

Although the story is delightful in itself, it also tells us something about the social history of art, about local customs, about the use of barter. More than this, the tale is a "novella" about the faith of a painter. It is like the tales in the lives of the saints, and it has a homey, "casalinga" flavor like that in the sermons of San Bernardino, whose hold over Tuscany, including Arezzo, depended on the vivid narrative style of his sermons, rooted in the tradition of Boccaccio. Here, however, it is Vasari who is telling the tale—the tale of an otherwise obscure painter who now, thanks to Vasari, becomes a memorable figure. He thus takes his place alongside the Aretine dignitaries whom he supposedly painted.

The Resurrection of Lazzaro

Lorentino's teacher, Vasari writes, was none other than Piero della Francesca, one of the greatest painters ever to work in Arezzo. Although he came from Borgo San Sepolcro, he made the important decoration of the True Cross in the church of San Francesco of Arezzo, a work that Vasari praises in a detailed description. In his life of Lazzaro Vasari, his ancestor, Vasari pretends that Lazzaro was a "great friend" and collaborator of Piero's, that sometimes one could hardly tell the work of one from the other. The implication of this endearing fiction is that Lazzaro is almost of the same stature as Piero: "Qui nescit dissimulare nescit vivere"—Who does not know how to dissimulate does not know how to live!

When Vasari brings Lazzaro back to life by composing his biography, he transforms him from a saddle maker into a painter. Perhaps Lazzaro did decorate his saddles with painted ornamentation, as Vasari claims, but it is more likely that he was little more than an artisan—scarcely a fresco painter like Piero. Lazzaro is also elevated in Vasari's fiction by virtue of his work for Niccolò Piccinino. Vasari pretends that Lazzaro painted the famous mercenary's "imprese."

The life of Lazzaro is an opportunity for Vasari to speak of his own lineage, of Lazzaro's son, Giorgio, Vasari's grandfather. It is the opportunity for Vasari to speak again of the family tomb that he built in the Pieve, where the bones of his father Antonio were placed. Building this sepulcher for his family, Vasari exhibits a devotion to family that he also discusses later in his autobiography when he writes again about the tomb and also about the support he gave to his sisters, whose dowries he provided.

The essentially imaginary Lazzaro is a typically Vasarian artist. "Pleasant and very wise," he lived an "honest life." His son Giorgio, Vasari's grandfather, collected ancient vases around Arezzo and rediscovered, we are told, the ancient means of making such vases. The Vasari, we recall, were so named because of their activities as "vasai" or vase makers. In a principal event in the life of Vasari's grandfather, told in the biography of Lazzaro, Giorgio gave to Lorenzo il Magnifico as a gift vases, which the illustrious recipient always kept in his house. The gift marked the beginning of Vasari's grandfather's service to the Medici, and, more deeply, it was the foundation of Vasari's own "servizio" to the Medici house. In this account, probably again a fiction, Vasari establishes the pedigree for his own attachment to the Medici, through whose glory he seeks his own.

The lives of Lazzaro and his progeny are thus crucial chapters in Vasari's own autobiography. When Vasari painted the posthumous portrait of Lorenzo de' Medici, to which we have already referred, he included a vessel with the inscription VIRTUTUM OMNIUM VAS, which is both a reference to Lorenzo as the vessel of all virtues and an emblematic signature. The vessel or vase upon which the inscription is found is also related to Vasari's tale of his grandfather's gift of such vases to Lorenzo, as if the picture memorialized this event, real or imaginary. Might Vasari have invented the story of the vases given to Lorenzo by Giorgio his grandfather out of the emblematic image in the portrait that he painted earlier? In any event, in light of the story of the gift to Lorenzo il Magnifico, the Vasarian vase in Vasari's portrait becomes symbolic of the Vasari family's earlier service to the Medici. The tale Vasari tells about his grandfather's gift and service to the Medici, whatever its origins and relations to the portrait of Lorenzo, is part of Vasari's aggrandized portrayal of himself. Of all deceits, self-deception is the easiest and what a man wishes, as Demosthenes observed, he believes to be true.

A Childhood Memory

In the family history of the Vasari, Giorgio introduces Lazzaro's nephew, Luca Signorelli of Cortona. Luca's biography is the final "vita" in the second part of the *Lives,* and here Vasari speaks of a childhood memory of the venerable artist. He tells us that the "good old man" lodged in the Vasari house for a time when he was eighty years old. When he heard that Vasari gave his attention during his lessons to drawing, he told Giorgio's father, "Antonio, if you wish little Giorgio not to become backward, let him draw, for even if he were to devote himself to letters, design cannot be otherwise than helpful, honorable, and advantageous to him, as it is to every gentleman." In Vasari's memory—or again is this a fiction?—Signorelli is a patrician among painters. The painter who so deeply influenced Michelangelo presents, with great authority, gravity, and love, the wisdom that Vasari repeats over and over throughout the *Lives*—that drawing is important, worthy of a gentleman. Gracious and courteous, as Vasari says, Signorelli was a "gentiluomo," an example to all artists.

To this story Vasari attaches another "memory." When he was a boy Vasari suffered nosebleeds that left him nearly dead from the loss of blood. For this Signorelli put around his neck and with his own hand a jasper, which was believed to have healing powers. He did this with loving care and, Vasari says, "this memory will stay forever fixed in my mind." It is an image of a wise, loving family patriarch, who seems to preside, almost mythically, over the beginning of Vasari's career, just as he stands as one of the founding fathers of the final or "terza maniera" in the history of art.

I Made, I Said

In his life of Ghiberti, Vasari expresses his displeasure with the artist, who, in his *Commentaries,* says, "I made, I said, I was making, I was saying"—"Io feci, io dissi, io faceva, io diceva," as Vasari writes disparagingly. Is this not, however, exactly what Vasari does throughout the *Lives,* writing, "I confess, I confirm, I learned from, I marvel at"? In the life of Tribolo, Vasari goes so far as to speak of "Vasari's modesty."

More often than not, however, Vasari, as we have already noted,

refers to himself not as "io" or "I" but as "Giorgio Vasari" or "Giorgio." In the life of Giovanni da Udine, he tells us of "Vasari" 's work in Camaldoli, Naples, and Rome. Throughout the *Lives*—in those already discussed, for example, the lives of Salviati and Signorelli and in countless others—we learn about "Vasari" 's travels and projects, about his collection of works of art, including antiquities and a copy after Michelangelo in his house in Arezzo. In the life of Peruzzi, we hear about the tour he gave to Titian in Rome; in the life of Giulio Romano, we learn of his trip to Mantua; in Perino del Vaga's biography, we find out about Vasari's work in Pisa, as in the life of Montorsoli we learn much about his establishment of the Accademia del Disegno.

The biography of Salviati is as much about the early life of "Vasari" as it is about his friend Salviati. Giorgio tells us of their studies in Rome, how hard they worked, drawing day and night. Reading of "Vasari" 's drawing, of his hard work, we recall Signorelli's advice that he apply himself to drawing; we are made to think of all those artists who, Vasari says, worked with great industry. He sums up this point about the need for hard work in the life of Lappoli. When Lappoli came to see "Giorgio" at work and to talk with him, he said, "Now I understand that hard work and study bring me through these difficulties and that our art does not come from the Holy Ghost." (Did Lappoli really say this or is this remark part of another fictionalized dialogue in the "autobiography" of the *Lives*?) Following Signorelli's lapidary advice, real or fictional, Vasari, in his industry, becomes, or makes himself into, an exemplary figure in the *Lives*—like Signorelli himself.

Vasari at Court

Vasari is forever talking about himself, filling in the details of his life, as he writes the lives of others. This is even true when he does not mention himself, since events in the lives of others are often related to or reflect his own experiences and feelings. When he speaks of Michelangelo retreating to Camaldoli, he reflects upon his own frequent visits to this holy place—to retire from the noise of the world, from the strains of court life. When he admires artists of the past for putting their art above a desire for financial gain, he is voicing his own

ideal, one that, he suggests, should always be followed by others. When he talks about artists past who showed love for each other, he is commenting on the jealousy and vicious competition of his own times, which he wishes did not exist. Whatever Vasari says about past art and past artists is written necessarily from the perspective of the present, from the perspective of his own life and times, and Vasari tells us enough about his autobiography throughout the *Lives* for us to see clearly how this is so.

Vasari tells us that he himself exhibited great love and affection to his artist-friends and disciples, to Gherardi, Mosca, Tribolo, and Salviati. He is like the fictionalized Gaddo Gaddi and Andrea Tafi, loving artists of the Trecento. Or rather Vasari makes up the fiction of these loving artists (he knows next to nothing about them in fact) to create the ideal of the loving artist, which he claims he himself later embodies. Was Vasari such a gentle, loving soul? Who knows? Certainly "Vasari" was! The biographies of his friends and protégés are stories of strife, or artistic rivalry among artists, who battle among themselves like warriors, who need guile and courtly skill to gain commissions. Himself a courtier, Vasari emerges, finally, as a kind of judge or princely figure of wisdom by helping other artists in their conflicts. He intervenes on behalf of his friend Salviati, who vies with Daniele da Volterra in the commission for the Sala Regia decorations, telling us elsewhere, of course, that he is also Daniele's "great friend." He assists the troubled Tribolo in his battles with Tasso, who is supported by the "sect" of Duke Cosimo's majordomo, the notorious Riccio; he intervenes in the conflict between Perino del Vaga and Aristotile da San Gallo; he speaks to the pope on behalf of Giovani da Udine, who is having trouble with Guglielmo della Porta, and, by a word to Duke Cosimo de' Medici, he helps to arrange for Gherardi's political pardon. Vasari is above all a courtier, and tells us of his mission to Rome to see Michelangelo on behalf of Duke Cosimo; he also observes that he presents Michelangelo's model for the Palazzo Farnese to the patron, as if he were serving as courtier to his artist-monarch. Even so, he ultimately paints a picture of himself resembling that of the princely Michelangelo: a self-portrait, in which Vasari is wise, superior, loving, above envy and greed, in which "Vasari" is like a monarch.

Vasari's role at court—as courtier who becomes princely—is summed up in an episode in the life of Tribolo. The artist was in

despair after an illness and Vasari, always his friend, who loved him greatly, as he says, told him not to lose heart. He arranged that Duke Alessandro de' Medici, would give him a job through the favor of Ottaviano de' Medici, into whose service Vasari introduced him. Tribolo then made copies in clay of the figures in the Medici Chapel, including a figure of Night, which he gave to Messer Giovanni Battista Figiovanni, prior of San Lorenzo, who presented the figure to Duke Alessandro. The duke, in turn, presented it to Vasari, who placed it in his house. In this story, Vasari emerges almost as a patron of another artist, and, receiving a gift of a work of art from his own patron, he is treated as if he were a princely patron himself.

The Return of Buffalmacco

We gradually see more and more clearly that virtually all that Vasari purports to write about the past is in fact about the present, about himself, about his own ideals, about his own vision of the world. When we return to the life of Buffalmacco, we discover a detail eclipsed by all the jests, which reminds us that, reading Vasari's book, we are always in the middle of the sixteenth century, squarely inside the life of Vasari himself. Speaking of the "varietà" of costumes and arms in the period of Buffalmacco, seen in the painter's work, he says, "I used them in the frescoes made for Duke Cosimo de' Medici"—by which he means the historical frescoes in the Palazzo Vecchio.

There is another curious way in which Buffalmacco reemerges in the mid-sixteenth century. In the life of Simone Mosca, Vasari tells us that a certain Bernardo di Cristoforo di Giovanni wanted an altarpiece in the chapel of the Badia of Santa Fiore in Arezzo, a commission offered earlier to Sarto and Rosso. The job came to Giorgio, who took his place in this illustrious line of artists. Vasari's problem was to place a giant figure of Saint Christopher, patron saint of the patron's father, in a restricted space. The giant, to be six *braccia* high, was to go in an altarpiece four *braccia* in height. Vasari solved the problem, we might say in his language, with great "ingegno." He made a design, he says, for the Saint Christopher "kneeling"; in this way the "monstrous" figure would fit into the space of the altarpiece.

This story bears a striking relation to a tale (already set forth above),

told by Vasari about Buffalmacco. The painter was to make a figure of Saint Christopher twelve *braccia* within a space of nine *braccia.* He solved the problem by depicting his figure lying down. The peasant who commissioned the work, furious, refused to make payment for the painting, but the officials of the tribunal made the judgment that Buffalmacco should be paid, since he had fulfilled the terms of his contract. This is one of the few tales about Buffalmacco in the life of Buffalmacco of Vasari's own invention. It is told right after Vasari speaks of his uses of Buffalmacco's costumes in his own art. Since Vasari made up his story about Buffalmacco, he could not emulate a real painting by Buffalmacco when he painted his own Saint Christopher. Vasari probably made up the story of his own Saint Christopher on the basis of his fiction about Buffalmacco. Although he tells us that his patron liked his invention for the kneeling Saint Christopher, he adds that the altarpiece was never realized, because the patron— most conveniently!—died. Of course there is no trace of the drawing Vasari says he made for this project. It is a fiction, like the fiction of Buffalmacco, in which the infinitely jesting Vasari plays a modern Buffalmacco, bringing him back to life in a cunning autobiographical tale that comments on his own wit. This episode is a fairly typical fiction in the autobiographical novel known as the *Lives.* Vasari's ficti- tious Saint Christopher is thus like the *Faun* Michelangelo pretended to have made for Lorenzo de' Medici, as I argued in *Michelangelo's Nose.* Vasari's ultimate cunning here lies not in a work of art as such but in a "novella" of great "ingegno."

Vasari's Revenge

In the life of Aristotile da San Gallo, Vasari tells us a great deal about himself. In particular, he presents a vivid portrayal of his enemy Iacone. Rather than study and work, Vasari says, Iacone and his friends gathered for dinners and parties, where they indulged in frivolous activities. They set their tables with cartoons for paintings rather than with proper tablecloths, and they drank from bottles. Professing to comport themselves like philosophers, they lived, Vasari says, like pigs and other beasts. Iacone and his pals hung out in their shops, maligning others. His gang consisted of Tasso, who (we previ-

ously saw) "taxed" others with disparaging remarks, and Piloto, who was murdered by a youth for his highly offensive remarks. Iacone was the worst of them all.

Having introduced this despicable character, Vasari now tells us a personal story about him. One day when Vasari was returning from Monte Oliveto, where he had visited the most reverend and cultured Don Miniato Pitti, abbot of the monastery, he encountered Iacone and his "brigata" or gang at the Canto de' Medici. Iacone, half in jest, half in earnest, spoke insultingly to Giorgio: "How goes it, Giorgio," he asked. "Well, my Iacone," Vasari replied, "once I was poor, like you, but now I have three thousand scudi or more." "You thought me a fool ('goffo')," Vasari continues, "but the friars and priests think me an able master. I used to be your servant, but now I have my own servant, who serves me and my horse. I used to dress in the clothes of poor painters, now I dress in velvet. I once traveled by foot, now on horseback. So you see, my dear Iacone, all goes well." Is this our gentle Giorgio speaking? Iacone is left, Vasari claims, out of breath, confused, stewing in his own misery. The moral of the story is that Iacone has been hoist with his own petard; the "ingannatore," the deceiver, was "ingannato" or made the fool. Iacone died, we are told, appropriately in a hovel in a little alley called Codarimessa. So ends in poverty the miserable life of a nasty wretch. Meanwhile, of course, the courtly, wealthy Vasari, prized by his patrons as an artist, a "valentuomo," continues to prosper and flourish.

Perhaps something like this encounter actually took place or, if it did, Vasari embellished it to magnify his triumph over Iacone. Perhaps it is a fantasy or fiction, Vasari's way in imagination of having his revenge against a hated rival. In either case, real or imaginary, Vasari reads this encounter back into the past, telling a similar story in the life of Dello Fiorentino. Returning from Spain, now a respected, prosperous artist after a youth spent in poverty, Dello was passing on horseback down the Vacchereccia, where there were many shops of artists, including those of his former friends who had known him in his youth. Either in fun or in mockery, they made scornful remarks to Dello, who, with both hands, made the obscene gesture of the "fig" before riding on aloofly. Those who mocked him were now the mocked. Because of this envy on the part of his former friends, Dello returned to Spain, where he continued to flourish at his craft, dressed in brocade. Or so Vasari pretends. Dello is, in this fiction, a Quattro-

cento type of Vasari, an artist gentleman, who rises above poverty and the mockery of rivals to live an honored life at court. Put differently, Vasari is a Cinquecento Dello. Who was Dello in fact? To Vasari (and to us still) Dello is but a shadowy name: a name given life in the fiction of the *Lives*.

You and Thou

Vasari's harsh feelings toward Iacone are part of the larger story of rivalries between artists in the *Lives*. In the life of Aristotile da San Gallo, Vasari intervenes in a dispute between Perino and Aristotile, presenting himself as a benevolent and wise intercessor. When Aristotile receives a commission for a stage perspective, Perino, indignant, is determined to give a "stima" or estimate of the work's value below its true value. Aristotile, hearing who is going to set the price on his work, addresses Perino to his face with the familiar "thou," as he had done when they were still youthful friends. Perino, already set against him, flies into a rage. This story echoes another episode in Vasari's biography, from the time when Aristotile first came to the Farnese court and addressed not only his cousin Antonio but all the nobles and gentlemen of the court with the familiar "thou." This episode, Vasari says, shows how out of step with the times Aristotile was.

Back to our story of Artistotile and Perino. Enter Vasari! When he hears from Aristotile of the conflict with Perino, he calmly tells Aristotile not to worry. He then speaks to Perino, delivering a long moralizing speech worthy of the finest speeches in the *Lives* by Brunelleschi and others in the manner of Livy or Thucydides. He addresses Perino most lovingly, he tells us, advising him not to undervalue Aristotile's work. He also does not fail to flatter Perino as he lectures him. He insists that a harsh judgment of Aristotile would be based on envy and malice and would be harmful to their profession. "Consider," Vasari concludes, "you do all the work in Rome, how would it appear to you if others were to value your efforts as you do his? Put yourself, I beseech you, in the shoes of this poor man, and you will see how far you are from reason and justice." At this Perino makes a fair estimate of Artistotile's work, and the affair is happily resolved. Thank you, Giorgio.

This story is another example of Vasari's judgment and wisdom, of his Solomonic intervention in a dispute, in which he appears dispassionate, remote from the vitiating emotions felt by Perino and Aristotile. (We know, of course, from his exchange with Iacone that he was capable of similar rage, even if he expressed it with courtly grace.) The related tale of how Aristotile addressed his cousin and others at the papal court as "thou" rather than as "you" tells us something of the difficulties of "borghese" artists encountering court etiquette. Vasari tells this story about the slightly ridiculous, if not goofy or "goffo," Aristotile from his standpoint as a suave, well-spoken, and aloof participant in the life of the court. Vasari idealizes himself by contrasting his own elegance and ease with the foibles of others. He portrays himself, as Michelangelo presented himself in his own autobiography dictated to Condivi or as Cellini did, dictating his life to a scribe, as a figure of courtly sagacity. Like Cellini and Michelangelo, he does this with Boccaccesque "novelle," by telling lively tales.

Vasari to the Rescue

Again in the life of Aristotile, Vasari writes about himself, by telling a tale about a key moment in his own life at court. This story concerns the decorations Aristotile made for a comedy to be performed for the wedding of Duke Alessandro de' Medici to Margherita of Austria in the house of Ottaviano de' Medici in the Via di San Gallo. The play was written by Alessandro's future assassin, Lorenzo di Pier Francesco de' Medici, who was in charge of the music and the overall production of the play. Lorenzo, Vasari tells us, was intent on killing the duke by whom he was favored and loved, and planned to do this by arranging props in such a way that they would fall on the duke and the audience.

Aristotile, Vasari continues, was aware of Lorenzo's evil scheme but could not make the villain desist from his preparations. He threatened to withdraw from the project when Vasari, a protégé of Ottaviano de' Medici and "at that time a mere lad," intervened. Vasari proposed a new plan for the production that would prevent Lorenzo from realizing his evil scheme, threatening also to speak to the duke about the dangers of the production as planned by Lorenzo. Rather

than risk being exposed in his evil plot, Lorenzo gave leave to Aristotile to follow Vasari's new directions. Thus, the duke and more than three hundred people were spared a horrible fate. Vasari had come to the rescue!

This episode is not discussed by historians and art historians concerned with the history of the Medici court, perhaps because they suspect, consciously or not, that it is not true. Vasari's story is not unlikely a fiction, resembling the self-aggrandizing tales in the life of Cellini, in which Vasari emerges as the savior of his lord and protector. Vasari's fantasy is nonetheless a valuable testimony to (or document of, as historians say) his devotion to Duke Alessandro. In the life of Tribolo and again in his own autobiography, Vasari tells us how shocked and upset he was by the duke's eventual assassination— "depressed," as we might now say. He was so distraught that he contemplated, as he says hyperbolically, leaving the court never to return. By imagining himself saving Alessandro, however, Vasari not only dreamed of how he might have saved his lord, but he also emerged a hero of the state. He memorializes his love for his patron in what we now call in Freud's wake a "wish fulfillment."

A. M. V. G.

Vasari's apostrophe to himself is most fully realized in his description of the work he did for his Medici patron, Duke Cosimo, in the Palazzo della Signoria, especially in the *salone*. In the *Lives*, Vasari's interventions there, both architectural and pictorial, emerge not only as part of his greatest work but as one of the greatest undertakings in the entire history of art.

Vasari's description of his work in the Palazzo della Signoria in his own "vita" at the end of the *Lives* is the dramatic culmination of a series of descriptions, building to a crescendo. In the life of Arnolfo, Vasari begins by telling us that Arnolfo built the Palazzo della Signoria, referring to Vasari's renovations in 1561 of a building "out of square" and originally awry. This description is followed in the life of Michelozzo by another reference to Arnolfo's work, followed by an account of how Michelozzo added to the courtyard of the palace. Then Vasari relates how "without ruining the old structure," he, Vasari,

brought the building into its better, improved form—with order, commodity, and proportion—now making it a fit habitation for the duke. With new walls and a splendid new staircase, as magnificent as a "public street," Vasari transformed this palace, like a castle, into "a new building." He says that if Arnolfo and Michelozzo could see this new building they would no longer recognize it.

The story of the Palazzo della Signoria is continued in the life of Cronaca, who built the *salone,* according to the recommendation of Savonarola, as the hall of the Gonfaloniere of Justice, where the Signori of the city convened. Although out of proportion, and given the speed with which it was made, it was, Vasari claims, the greatest hall ever built, greater than any built for the popes, than the hall in the castle in Naples, than the *saloni* in the palaces of Milan, Urbino, Venice, and Padua. Once again Vasari enters into the story, with a full, unabashedly self-serving account of his own renovations and fresco decoration. Vasari explains how he elevated the roof of the hall, then still ill-proportioned and inadequately lit, and also notes the contributions to the hall by Bandinelli and Ammannati, concluding that if Cronaca and others returned to life they would no longer recognize the palace or the *salone.* Still defective before Vasari's intervention, the *salone* is, in his own words, now "the largest, most magnificent, and most beautiful in all Europe."

Once again in the life of Tribolo we hear of Vasari's intervention in the palace after a discourse on the various errors of the hateful Tasso, who preceded Vasari as architect. He writes at length in the life of Bandinelli about the hall, again calling it the most beautiful in Europe. He speaks of the splendid "udienza" by Bandinelli, noting, however, an error in Bandinelli's portrait of Duke Cosimo, judged faulty because the men of the court said it did not look like the duke.

In the life of Ridolfo Ghirlandaio, Vasari repeats his self-accolade. He writes that, invited to the palace, the aged painter was carried there to dine. When he arrived, he admired the transformed palace, not recognizing it after its additions. Before he departed, he announced: "I die contented, seeing that I shall be able to carry to our craftsmen in the other world news that I have seen the dead restored to life, the ugly rendered beautiful, the old made young." Now all those artists who would not recognize the palace renovated by Vasari if they could see it will have news of this great architectural resurrection, because Ridolfo will take news of this miracle with him into the

afterlife. Vasari never mentions himself here, but no matter, for he is praising his own accomplishment in bringing perfection to the *salone* and palace by eliminating the defects of Arnolfo, Michelozzo, Cronaca, and Bandinelli. As Michelangelo was said to bring art to perfection, so did Vasari. When Ridolfo says that Vasari brought the dead building back to life, he says what Vasari had said about Michelangelo's breathing life into the dead stone that he carved in his sculpture. Ridolfo's words are likely Vasari's own put by him into Ridolfo's mouth. Just as Michelangelo distances himself from self-praise by dictating his autobiography to Condivi, told in the third person, Vasari creates a similar distance between himself and his professed greatness by putting his own praise in the mouth of another.

It is also appropriate that in the life of Michelangelo Vasari speaks of the divine Buonarroti's approbation of Vasari's design for the renovated hall. Michelangelo is the supreme judge of art, and Vasari, probably exaggerating Michelangelo's own language, if not inventing it, claims that Michelangelo wrote to Duke Cosimo, recommending that he follow Vasari's design, which was worthy of the duke's "own greatness." These are Vasari's flattering and self-flattering words, not Michelangelo's. For a brief moment he makes Michelangelo, praising Vasari, into his own Vasari. When Vasari says that his design for the *salone* brought more light into this darkened hall, we do not fail to recognize the parallel between his project and Michelangelo's contemporary dome for Saint Peter's, which Vasari praises for similarly allowing more light to enter the church.

In his own "vita" at the end of the *Lives*, Vasari presents his final self-glorification. His rhetoric is particularly telling in his ability to write about himself with the kind of "braggadocio" that we find in Cellini. Rather than speaking just of his own genius, he writes in still loftier terms of his "concetto" of the hall, "worthy of the heights and depths" of the duke's genius. He emphasizes the duke's "faith" in Vasari, Vasari's "good fortune" in being able to realize the duke's conception through the "grace of God." Vasari had earlier spoken of the *salone* as an "impresa," a great undertaking, like a battle, and here he talks of his painting of great "imprese" or battles, linking his labors, his overcoming of great difficulties coupled with a heroic vision of victory, which he pictures in the scenes of Florentine military victories.

When Vasari says that he painted "great figures" in the *salone*, he invokes the example of Michelangelo's heroic scale, and when he talks

about all the details in the depiction of battles, assaults, and triumphs, he alludes to Raphael's "varietà." The perfect artist, according to Vasari's "Libro del Artefice," is a synthesis of what is best in Michelangelo and Raphael and, in painting the *salone*, Vasari achieves such a synthesis and now becomes the very incarnation of this ideal, perfect artist. The ceiling of the *salone* illustrates the history of Florence from its origins to the apotheosis of Duke Cosimo de' Medici. In his *Lives* Vasari traces the parallel history of Florentine art from the "primi lumi" or first lights to his own apotheosis. Vasari fuses his own ascendancy with that of the Medici, whose glory, in which he participates, is the culmination, the perfection, the triumph of Florentine history and of the *Lives*. Ad majorem Vasarii gloriam!

Parallel Lives

Vasari goes on, in his own life, to describe his principal architectural works for Duke Cosimo in Florence and elsewhere in Tuscany. His catalogue includes the Uffizi, "nearly in the air," by which he means the structure is elevated on columns, the corridor linking the Uffizi to the Palazzo Pitti, the tribune of Santo Spirito, the church and palace of the knights of Santo Stefano in Pisa, and his renovations of both Santa Croce and Santa Maria Novella. We recall Vasari's early history of the latter church in the life of Gaddo Gaddi and his account of various works in the church by Brunelleschi, Masaccio, Ghirlandaio, and Filippino Lippi, among others—frescoes, sculptures, altarpieces, and tombs, described throughout the *Lives*—which now culminates in Vasari's renovations to the church.

Speaking of his own work, Vasari ranges between a celebration of its heroic grandeur and sublimity to a humble confession of his limits as architect. When he writes about the dome he built for Santa Maria dell'Umiltà in Pistoia, he characteristically both dwells sumptuously on the sheer grandeur and difficulty of this "terrible impresa" and offers a humble apology for its imperfection. Although his work in Pistoia is "very important," he appropriately says of a building dedicated to the Virgin's humility that "without excusing myself . . . if I have done good work, it is thanks to the grace of God." Vasari is, like Brunelleschi and Michelangelo, sublime in his heroic aspirations and

humble in his Christian resignation and recognition that what he has achieved is through the grace of God.

Vasari's continual emphasis on God's grace in his own life recalls his stress on God's role throughout the *Lives*. It reminds us of the piety of Michelangelo and even of Cellini. We are continuously called back to the recognition that, writing at mid-century, Vasari and his contemporaries epitomize the piety of the Catholic Reform. Vasari thus dwells on his religious works at Camaldoli, devotional projects not undertaken primarily for financial gain. His own religious zeal in the present, the moment in which he writes, is the focal point in the *Lives* for what he says about the religious devotion of artists from Cavallini to Fra Angelico, from Angelico to Michelangelo, about their piety, their love of God and their charity—all of which was reflected in their works. Vasari's image of himself as both a courtier who serves his ruler well and as a devout and humble artist who serves his Lord is the mirror in which he sees the artists who came before him. We might say that sometimes he creates them in his own image and likeness.

Of all the architects who precede him, the one who most resembles Vasari is Michelozzo, whose life is a veritable catalogue of architectural monuments made for Cosimo de' Medici, including the Medici palace, the building at San Marco and Santa Croce, and the villas at Careggi and Cafaggiolo. Duke Cosimo bolstered his own image by identifying himself with Cosimo "pater patriae," and Vasari exploits this identification by viewing Michelozzo as a kind of Quattrocento version of himself, undertaking architectural projects for his own patron's namesake. Just as Plutarch wrote parallel lives of the Greeks and Romans, Vasari writes the parallel lives, influenced by Plutarch, of fifteenth- and sixteenth-century artists. Celebrating Michelozzo's patron as "re" or king, praising his "magnificence," it is as if he were talking about the princely Duke Cosimo. At the heart of these parallel lives is the relation between Michelozzo's and Vasari's work in the Palazzo della Signoria. The relationship of Vasari and Michelozzo runs deep; it is based on what is even unstated. Vasari was not the greatest architect of his day; Michelangelo was. In this way, Michelozzo was eclipsed by Brunelleschi, who was the type of Michelangelo, a Quattrocento Buonarroti.

When Vasari says that Michelozzo "loved" Cosimo, he is also speaking of his own devotion to Duke Cosimo. When he says that Michelozzo dined at table with Cosimo, he is speaking of his own

place in the household of Duke Cosimo, and when he says that Fra Angelico portrayed Michelozzo as Nicodemus in his *Deposition of Christ*, he is not only referring to the tradition that Nicodemus was a sculptor, like Michelozzo, but he is also commenting on Michelozzo's Vasari-like piety. Vasari embellishes this relation of Cosimo and Michelozzo by saying that Michelozzo accompanied his patron into exile, returning with him "nearly triumphantly." Vasari had left the Medici court after the assassination of Duke Alessandro only to return, similarly after the triumphant ascendancy of Duke Cosimo. As we have already seen, Vasari linked his own artistic triumph to the duke's political hegemony—reasonably enough, since his artistic accomplishment depended on Cosimo's patronage. Like Michelozzo, Vasari was a loving, devoted servant of the Medici, who undertook important works for his Medici patron.

The Medici Triumphant

Vasari's work in the Palazzo Vecchio, discussed over and over again throughout the *Lives*, is work that becomes an important culmination of his life and artistic career, as it is the culmination of the history of art. More than this, it is, in civic terms, the culmination of the history of the city and, in the history of the city, the culmination of the rise of the Medici to power. The importance of the Medici in Vasari's *Lives* is so well known that we need not review it in full here. Suffice it to say that Vasari's is a history of Medici patrons, from Cosimo de' Medici, "pater patriae," to Cosimo de' Medici, Duke of Florence. As part of this history, Vasari stresses their role in reviving antiquity, their patronage and collecting of art, their commissions of major monuments and works by Angelico, Lippi, Botticelli, Raphael, Michelangelo, and Vasari himself.

Throughout this history, which belongs to the vast history of writings in praise of the Medici, Vasari celebrates important moments in the rise and fall and return of the Medici—from the rise of Cosimo to his return from exile, from the exile of Piero to the triumphant return of Leo X, from the assassination of Duke Alessandro to the rise of Duke Cosimo. He writes extensively about the patronage of Clement and Ottaviano,

and he never misses an opportunity to praise the virtues of all these celebrated members of an illustrious family, speaking of their patronage and their love of arts and letters. He is forever identifying their tombs, their effigies in portraits, altarpieces, and frescoes, often seeing them in paintings when they are in fact not there. The culminating moment in this history is the above-mentioned image of the apotheosis of Duke Cosimo, depicted by Vasari in the ceiling at the center of the *salone* of the Palazzo della Signoria, which became the duke's residence. By painting it as the principal, final, idealized image in the history of the Medici, Vasari participates, as we have seen, in their very effulgence.

Although Vasari painted the history of the Medici in great detail throughout the new Medici residence, these decorations, significant though they are, have contributed less than the *Lives* to the immortality of the family. It is Vasari's descriptions, for example, of Cosimo locking Lippo up in his palace and joking about the painter's amorous appetites or his spacious word-pictures of Pontormo's parade decorations, celebrating the triumph of the Medici, or his intimate, if fantasized, portrayals of political intrigue at the court of Duke Cosimo (where he is an active participant and observer) that keep the image of the Medici before us. Even if we have never known Machiavelli's, Guicciardini's, and Varchi's less widely read histories of Florence, the Medici remain in our imagination primarily because Vasari's *Lives* keeps them there. His artistic triumph depends on his descriptions, which create convincing three-dimensional images of the Medici. They appear before us in Vasari's prose, as in a painting, in relief. His triumph depends, as I have said (and it bears repetition), on his skill as a storyteller, as teller of tales, on his ability to describe—whether he is telling us the funny tale of Duke Cosimo's gift of a cape to Gherardi or picturing in words the magnificent garden of the Medici at their other residence, the Palazzo Pitti, the gardens of which are, like the city itself, a paradise. If the Renaissance still lingers in our imagination as a sort of paradise, a glorious and heroic period, a golden age of culture, the age of the Medici, this is in no small measure thanks to Vasari, who is more than a panegyrist and self-promoter, whose book is more than a long chapter in the historiography of the Renaissance, for what he achieved in his lively and vivid fictionalized history or historical fiction he attained through the energy or "forza" of his masterly prose.

History and Novel

Vasari's *Lives* is unequivocally a history, though not a history of the kind modern art historians would write today. Why not, we may ask? Because Vasari's history is one rooted in fiction, filled with imaginary artists, events, epitaphs, tombs, emblems, speeches, anecdotes, and interpretations of works of art that transform their meaning, giving them new significance. Margherita Acciaiuoli's speech, as we saw, is largely imaginary, and Vasari's description of Joseph as a kingly figure in Pontormo's panel has more to do with the meaning of Joseph as ruler in the court of Duke Cosimo than with his meaning in the Borgherini painting itself. There is of course much valuable information in the pages of Vasari of which historians make good use. Among all the fictions, errors, and misinformation, there are mother lodes of facts: locations of works, dates, names of patrons, and, above all, the critical and theoretical language in which these works are described.

I have emphasized that as history the *Lives* is principally a portrayal of art and life in Vasari's own times, Vasari's picture of events present and past, always seen through the present. How Vasari saw, envisioned, imagined, and transformed what was available to him is in itself a valuable historical record. Vasari is a great fantasist in his responses to art, but this fantasy is itself a historical document; it is part of the story of how a single individual beheld and conceived his own life and world and their origins.

Let us pause to review our perspective on Vasari, on some of the ways in which we can experience his book. If he wrote his history in the form of a series of biographies, he transformed these biographies, as we observed, into his own biography. If he fashioned an ideal artist, a colossus who was born in the thirteenth century and who reached maturity in his own lifetime, he, Giorgio, participated in the life of that fictitious artist at every stage, appearing and reappearing, as we saw, in the various biographies that make up the stages in the development of that ideal artist. He intervenes by responding to the works of past masters, by restoring their works, by telling stories about them, by standing in front of them, by talking about them, by summoning them to memory as he sits at his desk writing. Like the poets who are forever transforming themselves and their materials, Vasari transforms history, biography, and autobiography into fiction in the form of a sustained series of "novelle." Dante, as we have seen, is his model

for the larger biblical allegory of his work as a journey of the artist-pilgrim from darkness to light and perfection, as Boccaccio is for the devices of narrative instrumental in the telling of his monumental tale.

Although Vasari's history of art is a "Divine Comedy" of art, culminating in the heavenly perfection of the final Dantesque pilgrim, Michelangelo, it is also a comedy like Boccaccio's. Like Boccaccio and his imitators, Vasari writes both comically and morally about the appetites and vices of the artists, against which they should struggle—of their lusts, of their greed, of their vainglory. Like Boccaccio, Vasari writes a human comedy, in which the principal characters realistically express their passions, their rage, joy, lusts, and sorrow. They are like the characters that Vasari says Buffalmacco painted. Vasari says this because Buffalmacco is himself a Boccaccesque character, who in a sense painted himself in his art with Boccaccesque realism.

History, biography, autobiography, fiction, Vasari's book is also a history of a city, of Florence. As such, it is *sui generis*, for if Machiavelli, Guicciardini, and others wrote histories of the city, like the ancient histories of Athens and Rome, like the modern histories of England and France, which are the histories of great statesmen and of political institutions, Vasari wrote a physical history of the city—not just a history of architecture but a history of the building of the city, brick upon brick, stone by stone. Nowhere, not in Suetonius, not in Braudel, does one find with such scope and vivid detail a sustained description of the raising of palaces and churches, of domes and towers, of the decorations of these structures. So detailed is this physical history of a place, so animated by the conversations and interactions of the city's builders and decorators, that one could reorganize this history into a guidebook of Florence, containing all the details concerning the decorations of the principal palaces and churches of the city.

As a rich, complex, fictionalized history of a city, of its various families, politically powerful or artistic, as a history of ambition, greed, sorrow and joy, of triumph and failure, as a vast panoramic history of interrelated characters that unfolds from one generation to the next, Vasari's book resembles the complex of novels by Balzac collected as the *Comédie Humaine*—a title that still echoes Dante. If Balzac was later the "secretary" of Paris, Vasari held the same position in Florence. Vasari was a sixteenth-century Balzac, his *Lives* a *Comédie Humaine avant la lettre*. No wonder so many nineteenth-

century novelists, particularly French novelists, novelists writing about Paris, looked back, as we noted at the outset, to Vasari's great literary monument, for the fictional pageant of his book made of it an important rootstock of the modern historical novel, especially the novel about the life and times of the artist.

The supreme book in this tradition is of course Proust's great novel. The relation of Proust's book to Vasari's *Lives*, by no means apparent, is deep, because the protagonist of his novel, Marcel, the author's autobiographical surrogate, plays a role first given definition in prose by Vasari when he created the "Giorgio" of his autobiographical novel about art known as the *Lives*. This is not to say that Vasari's book is Proustian, but it is to say that Vasari's vast novel about Florentine society, which tells us so much about its customs, mores, etiquette, and social history, which is a fictionalized life of the artist, is an ancestor of Proust's own monument. As the inventor of the modern autobiographical novel of the artist, Vasari deepens Burckhardt's claim that the Renaissance is the beginning of the modern world.

It has become commonplace, if not fashionable, to speak of the way in which great writers create themselves through their books. Proust is one of the supreme examples of such self-creation. We should not forget, however, that this phenomenon has its earlier roots at the dawn of the modern period in Dante, who created the "Dante" of his *Comedy*, the "Dante" who is not just a character in Dante's book, but the Dante who is synonymous with his book. In this way Vasari is not only the author of a book about "Vasari," he is identical with his book. Just as Dante is the *Commedia* before him and Proust is *A la recherche du temps perdu* after him, Vasari is the *Lives*.

Proust's book is also linked to Vasari's in aesthetic terms. Proust's view of the world is informed by Vasari's theory of art, as distilled by Bernard Berenson, whose books Proust knew by heart. Speaking of the kitchen maid, Proust compares her to a photograph of Giotto's "Caritas" given to Marcel by Swann. "Well, how goes it with Giotto's Charity," Swann would say to her. For Proust, Giotto's figure reincarnates the very virtue she personified, and he says that Giotto's frescoes are not symbols as such, because they embody "real things actually felt." They are rooted in reality, like that of the young kitchen maid "swelled" in pregnancy. Like Berenson, Proust, responding to Vasari, dwells on the "significance" of form, on the sense of the "material" conveyed by tactile values—on what Vasari calls "rilievo" or relief,

which is achieved through chiaroscuro. For Vasari certain artists—Giotto, Masaccio, and Michelangelo—rendered "cose essenziali," essences, and Proust meditates on the larger meaning of this idea, seeing the link between Giotto's allegories and their "being" or essence in reality. Imagining fictitious characters, Proust relies on Vasari's way of describing works of art, which articulates the reality that they embody, the reality that they imitate.

Proust's indebtedness to Vasari is even more immediate in his use of Mantegna. At a reception, Swann beholds a lad in livery who "stood musing, motionless, statuesque, like that purely decorative warrior in the most tumultuous of Mantegna's paintings, lost in dreams, leaning upon his shield." This is the "naively romantic" Mantegna of Berenson, who painted his figures "as if they had never been anything but marble, never other than statuesque in pose." And Berenson's is still Vasari's Mantegna, who imitated ancient sculptures in marble to such an extent that his figures "resembled not living figures but ancient statues," as Mantegna's teacher says in an imaginary speech in the *Lives*. No matter that Vasari is criticizing Mantegna's petrified figures for their excessive artificiality. What is significant is that Vasari established the way of describing Mantegna's lapidary art and that this marmoreal ideal still informs the way in which the novelist describes his characters. Vasari did not invent the device of describing a character, real or imaginary, by comparing him or her to a work of art, a device already employed in antiquity, as it has been said, but he codified this approach at the beginning of the modern period in his descriptions of characters whose reality depended on the characteristics of their own art—the harsh Castagno, the fleshly Lippi, the angelic Angelico, and the violent Bandinelli. Proust inherited this tradition from Vasari through Berenson and others, seeing his characters in attitudes and postures reminiscent of the sculptures and paintings he had once seen and now remembered from photographs.

Proust's "picture" of reality depends not only on the pictures of the Italian Renaissance but also on the way in which these pictures were translated into language in the Renaissance—on a tradition of rhetorical or poetical description that has its taproot in Vasari. Proust's Parisian society is imagined not only in terms of art but also in the terms of Vasari's descriptions of that art; Proust's horizons are expanded by Vasari's spacious view of the relations that obtain between art and the society in which it was made.

Vasari's Banquet

Nowhere does the fiction of the artist-hero emerge more vividly in the pages of Vasari's book than in the well-known, often quoted passage of his own "vita" in which he discusses the origins of the *Lives*. In a tale always recognized to be a fiction, Vasari pretends that the idea of writing the *Lives* was given to him when he was at dinner in Rome with Cardinal Farnese and the leading men of letters of the day—Molza, Caro, Tolomei, and Giovio. Transcribing this imaginary dinner-table discussion, Vasari has Giovio ask, "What do you say, Giorgio, would not such a book [the *Lives*] be a beautiful work?" Yes, Vasari agrees. "Good," Giovio continues, "I want you to undertake it," and Vasari adds that from that moment on he was resolved to do so. As in Castiglione's *Book of the Courtier*, Vasari records the imaginary, if plausible, conversation of real-life characters. Clearly, however, Vasari had in fact already planned such a work before the imagined dinner-party discussion of the mid-1540s, as it has often been observed, since the *Lives* appeared just a few years later, in 1550: merely human industry, merely mortal talent, not even the two in some unprecedented confluence, could have accomplished so much in so brief a span of years. Vasari wanted to establish himself among the leading literary figures of the day, and he did this by idealizing the creation of his book, memorializing the inception of his great literary monument, sanctioned by his distinguished literary friends, at a banquet. He made this event a key moment in the autobiographical fiction of his *Lives*—a moment that has become fundamental to the mythology of his book and its origins.

The setting of the imaginary origins of the *Lives* has everything to do with the literary character of the book, for if we read the *Lives* as biography and autobiography, as history and fiction, we should also read it as a work belonging to the tradition of the literary symposium or banquet. Food and drink are ever present in the *Lives*. Sometimes this food and drink are deeply spiritual, as in the various spiritual banquets that Vasari painted in refectories and described prominently in his own "vita." In Bologna at San Michele in Bosco he depicted, he says, Saint Gregory at table with the twelve poor men, Christ in the house of Mary and Martha, when Martha ordered a meal or "convito" most lovingly, and Abraham setting the table for three angels. Vasari here emphasizes the trinitarian symbolism of these three works, including the three angels. Vasari also tells us that he painted three other holy meals in San

Pietro in Perugia: the Marriage at Cana; Elisha making sweet with meal the bitter pot; and the story of Saint Benedict given large quantities of wheat by angels. The last three paintings of spiritual food are all miracles, examples of heavenly intervention.

Vasari transforms such spiritual banquets into worldly events. In his painting of Esther and Ahasuerus in Mantua, the scene, as Vasari describes it, is regal and magnificent; it includes pages in livery and a sideboard weighted with bottles. Despite its sacred subject, this supper approaches the unheavenly banquet for the wedding of Cupid and Psyche, painted in Mantua by his friend Giulio Romano. Here we see, as Vasari tells us, a splendid sideboard, arched over by a trellis laden with grapes and crowded with various goblets in gold and silver. Such is the imagery of a banquet for the pagan gods. It is like the banquet of the gods pictured by Raphael in a loggia of Agostino Chigi's villa in Rome—an ideal banquet mirrored in the actual marriage feast and other affairs at table in the villa. Such banquets abound in the lives of the artists themselves; Vasari writes at length and in great detail about these feasts in the life of Rustici. Members of clubs called the Company of the Trowel and the Company of the Cooking-pot used to make elaborate gastronomic confections—including Sarto's famous replica of the Baptistry, made mostly out of marzipan—and these works or "invenzioni," works of art in their own right, reflected considerable "virtù." We usually take Vasari's account of these suppers at face value and, although his reports may depend on knowledge of such customs and feasts in Florence, it is not impossible that he has embellished them in a gastronomic "fantasia."

Vasari often describes his artists at table: Ridolfo Ghirlandaio at dinner in the Palazzo della Signoria, the young Michelangelo at table with Lorenzo de' Medici, Raphael at dinner with Taddeo Taddei, and Brunelleschi at supper with Toscanelli. Brunelleschi, we recall, had invited Donatello to dine with him when the latter dropped the eggs and cheese he brought with him, stunned by Brunelleschi's *Crucifix*. Donatello, whose prophet was named after a pumpkin, was on the way to market to shop when he stopped to mock Uccello, who ate so much cheese at San Miniato that he thought he was becoming cheese, and Donatello, forever generous and associated in Vasari's imagination with food, agreed to help Nanni di Banco with the *Quattro Coronati*, if the latter would buy lunch for all his assistants. Eating could become the topic of joking. When Albertinelli quit painting for

a time and opened an inn, he quipped that now he produced real flesh (on the bodies of those who ate there, as he implies), not merely the illusion of flesh in painting. His companion Fra Bartolommeo died, Vasari says, after eating figs, which were otherwise a subject of delight. Michelangelo sent Indaco out for figs as a ruse, we remember, and Giovanni da Udine painted figs, Vasari tells us, as part of a sexual joke, appropriately next to Raphael's banquet of the gods in Chigi's villa.

Food is always understandably on the minds of painters. David Ghirlandaio and Albertinelli's disciples, we learned earlier, are dissatisfied with the food given them by their ecclesiastical patrons. Lorentino needs a pig before carnival, and Visino misses the good Trebbiano wine and pastry of Florence when he is away in Hungary. The crabby Aspertini tells a friend, "Go cook a cabbage," and Lorenzo di Bicci says, "Put the kettle up, I'll be along in a minute"—by which he means that he paints very fast. Buffalmacco, we also remember, is interested in wine, and he ruins Capo d'oca's food by putting too much salt in it.

We follow Vasari and his fellow artists from heavenly and courtly banquets into taverns and shops—like those where Niccolò Grosso and Iacone set their tables like swine by using cartoons, where Iacone downs his wine out of a bottle. He is one of Vasari's numerous "Beoni" or Big Drinkers—to borrow the title of a funny poem by Lorenzo de' Medici—and he includes Perino and Sebastiano among them. Sebastiano, Vasari says, turned rubicund from drinking wine, no doubt like the figures painted by Buffalmacco after he was given Vernaccia to drink. If many artists are gluttons, others are spiritual in their habits at table, like the very saints pictured by Vasari in heavenly repasts. Michelangelo, who eats and drinks only bread and wine, is like the monks and nuns eating simple food in the refectories decorated by Vasari. Some artists are simply eccentric in their eating habits. Piero di Cosimo, for example, restricts himself to hard-boiled eggs. Eggs are also useful metaphors: the broken egg, which Brunelleschi uses to visualize the dome of Florence, and the eggs his friend Donatello drops, expressing his "maraviglia" when he sees Brunelleschi's *Crucifix*.

Eggs, cheese, bread, figs, cabbage, pork, pastry, marzipan, wine—these are some of the delights of Vasari's banquet, which ranges from the macaronic or "kitchen humor" to the royal banquet or spiritual repast; from the low life of taverns and artists' shops to the banqueting

halls of courts, including the court of heaven itself. Vasari's banquet, like his book, is plentiful in its offerings, bountiful in the delights it serves up to us. With good food comes conviviality and good talk. The talk is often of good wine, and many of Vasari's good drinkers are guzzlers like those at Rabelais's banquet. Their talk is often chatter— the "gracchiare," "ciarlare," and "chiacchierare" of eccentrics or brutes. Often, however, it is refined, learned talk or "discorsi," the "ragionamenti" of men and women of station, of culture and learning, "the sweeter banquet of the mind": the talk of Vasari and his friends at supper with Cardinal Farnese; of Michelangelo at table with Lorenzo de' Medici. These artists, like Vasari's very book, belong to the tradition of the literary and philosophical banquet, which includes Rabelais's book, Castiglione's "symposium" at Urbino, Dante's "Convito," Petronius's *Cena*, and, ultimately, Xenophon's and Plato's symposiums, banquets most philosophical.

We leave Vasari's banquet, the banquet of his book, contented and edified, ready to return again another day. Why? Precisely because with all the good food, there is good talk, talk that nourishes. Vasari, who speaks in a high literary style, in slang, in proverbs, in word-games, in poetry; Vasari, who talks of art and literature, of love and politics, of success and thwarted ambition, of talent realized and talent misspent, of defeat and triumph, of folly and wisdom, of rage and friendship, of devotion and betrayal, of clothes and manners, of lords and kings, boors and boobies, clerics and soldiers, patriarchs and heroines, palaces and churches, streets and piazzas, of great events and quotidian routine, of heaven and hell; Vasari forever garrulous, forever chatty, forever talking—like the greatest talkers, like Lucian, Boccaccio, Chaucer, Erasmus, Rabelais, like Montaigne, Burton, Diderot, Sterne, Dickens, and Joyce—Vasari, Giorgio Vasari Aretino, offers us a banquet of most convivial, unending talk, and for this talk, in the many voices of the *Lives*, we remain eternally grateful epicures.

BIBLIOGRAPHICAL ESSAY

Most readers today who encounter Vasari for the first time in English translation do so in the two Penguin volumes of selections by George Bull (vol. 1, 1965; vol. 2, 1987). Those who choose to read the entire book in translation will find the earlier version of Gaston Du C. de Vere (1913) reprinted in three volumes with an excellent introduction by Kenneth Clark (1979). The latter translation is relatively closer to the periodic style of Vasari's Italian; Bull's is keyed to the taste of the modern reader, who prefers shorter sentences. Bull's translation, while lively, sometimes approaches paraphrase. It eliminates much of Vasari's theological and technical language and therefore the meaning of that language. As I write, Julia and Peter Bondanella have finished a translation of selections from Vasari, which is to be published by Oxford University Press. The beginning reader of Vasari who wants to learn more about him can turn to Boase's book, *Giorgio Vasari: The Man and the Book* (1979), which contains a survey of Vasari's career, a broad summary of the *Lives*, and a useful introductory bibliography.

For readers who will turn to Vasari in the original, the classic, often-reprinted Milanesi edition (1878–85) is still very useful. All scholars of Vasari are now indebted to Paola Barocchi for her publication of the 1550 and 1568 editions (from 1966) and for her critical edition of the life of Michelangelo (1962). I have relied principally on the Club del Libro edition (1967), which is valuable both for its copious art-historical notes and for its occasional insights into the literary character of the *Lives*.

The scholarly literature on Vasari is vast. It includes classic, techni-

cal studies of Vasari's language by Scoti-Bertinelli (1906), Kallab (1908), and Ragghianti (1933). In his various writings on Renaissance art and its criticism, Roberto Longhi is particularly helpful in showing how Vasari's language helps us to look at Renaissance paintings and interpret them visually. Also helpful in a similar way, though written from a different perspective, is David Summer's monumental book on the "language of art" (1981). For inclusive recent bibliographies of Vasari, see the exhibition catalogue for the exhibition in Arezzo, *Giorgio Vasari: La Toscana nel '500* (1981), and Wazbinski's more recent book on Vasari and his academy of art (1987).

Julius von Schlosser's chapter in *La Letteratura artistica* is still very helpful as an introduction to the art-historical and literary character of Vasari's book. Schlosser speaks of the "typology" of the *Lives*, a topic elaborated upon by Giovanni Nencioni and, more fully, in a book on the first edition of the *Lives* by Laura Riccò (1979). An understanding of the typology of the *Lives*, as I have suggested here, is fundamental to our recognizing that what Vasari says about the art of the fourteenth and fifteenth centuries is implicitly a commentary on the art of his own times. Typology also helps us to see that sometimes Vasari reuses Trecento fictions in the supposedly "true" stories of his own contemporaries. Of related interest, Barbara Mitchell's unpublished dissertation on Vasari (1975) is particularly valuable for the connections it makes between different stories about patronage in the *Lives*.

Despite the predominantly philological work on Vasari, the literary study of Vasari is underdeveloped. Francesco Flora's pages on Vasari (1941) are still an excellent introduction to the vivid style of the *Lives*. Jean Rouchette's compendious book (1959) is also of interest, because of its observations on Vasari's prose style in relation to that of his contemporaries. In a recent book (1985), James Mirollo has discussed Vasari in relation to the concept of literary Mannerism. On the basis of this approach more work might be done by applying Vasari's theoretical language to his own book—as a guide to itself (which would perhaps have delighted Vasari). For the most part, however, Vasari is used primarily as a source for the definitions of the Renaissance as a historical period and of Mannerism as a stylistic and historical category. Scholars of Renaissance literature writing in English have little to say about the *Lives*. They write about Dante, Petrarch, and Boccaccio, about Poliziano, Bembo, and Sannazaro, about Machiavelli, Castiglione, and Ariosto, about Cellini, Tasso, and Della Porta, about

Nicolas of Cusa, Erasmus, and Thomas More, about Ronsard, Rabe-
lais, and Montaigne, about Spenser, Shakespeare, and Jonson, but
they leave Vasari to the art historians, who write about Vasari's literary
character in a narrower art-historical context. Especially notable
here, however, is Svetlana Alper's essay (1961) that considers Vasari's
place in the specific tradition of "ekphrasis," that is, the rhetorical
description of art.

One might include here an instructive nonbibliography of Vasari,
noting all those places where we should expect Vasari to be discussed
but where he is absent. There is no mention of Vasari in Northrop
Frye's seemingly universal study of literature, *Anatomy of Criticism*,
and Vasari is absent from Wayne Booth's *Rhetoric of Fiction*. The fact
that it did not occur to these two great scholars to dip into Vasari's
pages while preparing their vast literary projects on world literature
says much. The omission is not surprising. I recently met a very
distinguished literary scholar working on biography in the modern
period who told me that she had never bothered to read Vasari.

Every author has his or her hobbyhorse, and I have furiously rid-
den mine into the *Lives*. I have urged that Vasari be read for his own
sake, not merely as a gloss to the art of others. I have also stressed that
his book is more profoundly fictional, and hence poetical, than is
supposed, especially by art historians. The author of a recent mono-
graph on a major Renaissance artist lamented the absence of anec-
dotes in Vasari's biography of the artist, as if to suggest that such
anecdotes would tell us more about what "really" happened in his life.
This acceptance of Vasari at face value is fairly typical of art history,
notwithstanding the fact that art historians otherwise correct his attri-
butions and inaccurate dates.

I have also urged that we sharpen our focus on the fact that Vasari
wrote during a particular historical moment, in the middle years of the
sixteenth century. By doing this, we come to recognize more clearly
how it is that what Vasari imagines is the record of a particular historical
era. Vasari's fictions and fantasies are a historical document—the rec-
ord of his own life and times, of his own aspirations. His so-called errors
are historically determined. The full analysis of Vasari's picture of life at
the Medici court—which is woven in fantasy through his book—is still
to be written.

My reading of Vasari here is an essay that by no means exhausts the
possible approaches to the *Lives*, that offers suggestions for reading

his book to be taken up in the analysis of passages unremarked here. Future readings of the *Lives*, however, will need to be based on a deeper knowledge of the entire book, not on selections. The *Lives*, like Gibbon's *Decline and Fall of the Roman Empire* or Henry Adams's *History of the United States*, is so vast that readers, even scholars of art history and literature, seldom read the book all the way through. They often fail to grasp the book's larger structures and literary implications; they miss much in the unread lives of minor artists that are rich in literary detail and meaning.

We might imagine Vasari's spacious book as a vast country, often explored by scholars, who have led tourists to a number of spots by now familiar. Large tracts of this imaginary land are, however, unvisited, and few visitors have traveled through the republic of Vasari in its entirety, crossing all of its mountains, fording its rivers, penetrating its forests. This country has its deserts, to be sure, those tedious lists of works, those speeches that become just a bit too pompous. Even Homer has his catalogue of ships and Ariosto his long genealogy of the d'Este. It is necessary to pass through these deserts in order to find the hidden oases, the splendid gardens rising up here and there in the land of Vasari. Many of the tourists who know Vasari well know only specific sites. They return to them often, not realizing what buried treasures lie beneath their eyes in the grottoes of Vasari's literary artifice.

Thus, the imaginary country of Vasari still awaits its Marco Polo, its Columbus, its Livingstone—even its Phileas Fogg! If students of Renaissance literature will travel more often to this land, joined on their expeditions by art historians, they will return from these goodly states and kingdoms with treasures far greater than anything of which they previously dreamed. I have made extensive annual trips to this realm of gold for over thirty years, bringing back with me but a few precious nuggets, a clue to what still lies buried in his book, waiting to be unearthed. Amateurs, too, devotees of good stories, are invited to come on such an expedition, and they can profit from and enjoy the sights and delights of such a journey without bringing the pick-axes, ropes, cables, and technical maps of scholarly apparatus.

One final caveat, gentle reader, before you depart or depart again: remember that the land of Vasari to which you travel is not just the capital of art history, a minor if not uninteresting principality in the

domain of letters. Vasari is a major state in the larger republic of literature. That lusty Lippi, heavenly Angelico, and cruel Castagno, mysterious Leonardo, courtly Raphael, and divine Michelangelo live in legend, endure in imagination, reminds us that this is so. Buon Viaggio!

SELECTED BIBLIOGRAPHY

Alpers, Svetlana. "Ekphrasis and Aesthetic Attitudes in Vasari's *Lives.*" *Journal of the Warburg and Courtauld Institutes* 23 (1960): 190–215.

Boase, T. S. R. *Giorgio Vasari: The Man and the Book.* Princeton, 1979.

Flora, Francesco. *Storia della letteratura italiana,* vol. 2. Milan, 1941.

Giorgio Vasari (La Toscana del '500). Florence, 1981.

Kallab, Wolfgang. *Vasaristudien,* ed. Julius von Schlosser. Vienna and Leipzig, 1908.

Longhi, Roberto. "Proposte per una critica d'arte." *Paragone* 1 (1950): 5–19.

Mirollo, James V. *Mannerism and Renaissance Poetry: Concept, Mode, Inner Design.* New Haven, 1985.

Mitchell, Barbara. *The Patron of Art in Giorgio Vasari's Lives.* Ph.D. dissertation, Indiana University, 1975.

Nencioni, Giovanni. "Premesse all'analisi stilistica del Vasari." *Lingua Nostra* 15 (1954): 33–40.

Ragghianti, Carlo. "Il valore dell'opera di Giorgio Vasari." *Critica d'arte* 26 (1980): 207–59.

Riccò, Laura. *Vasari scrittore: La prima edizione del libro delle "Vite."* Rome, 1979.

Rouchette, Jean. *La Renaissance que nous a leguée Vasari.* Bordeaux, 1959.

Schlosser, Julius von. *La Letteratura artistica,* ed. Otto Kurz, 3d ed. Florence, 1964.

Scoti-Bertinelli, U. *Giorgio Vasari scrittore.* Pisa, 1905.

Summers, David. *Michelangelo and the Language of Art.* Princeton, 1981.

Vasari, Giorgio. *Lives of the Artists,* trans. George Bull, 2 vols. Harmondsworth, Middlesex, 1965 and 1987.

———. *Lives of the Most Eminent Painters Sculptors and Architects,* trans. Gaston Du C. de Vere, 3 vols. New York, 1979.

———. *Le vite de' più eccellenti architetti pittori et scultori italiani da Cimabue insino a' tempi nostri,* ed. Luciano Bellosi and Aldo Rossi. Turin, 1986.

———. *Le vite de' più eccellenti pittori scultori e architettori,* ed. Paola della Pergola, Giovanni Grassi, and Giovanni Previtali, 9 vols. Novara, 1967.

Wazbinski, Zygmunt. *L'Accademia Medicea del Disegno a Firenze nel Cinquecento: Idea e Istituzione,* 2 vols. Florence, 1987.

INDEX

Acciaiuoli, Margherita, 65, 66, 67, 70–71, 75, 76, 79, 108
Adams, Henry, 120
Alberti, Leon Battista, 73
Albertinelli, Mariotto, 25, 113, 114
Alfonso Ferrarese, 29–30, 36
Allori, Alessandro, 69, 70
Alpers, Svetlana, 119
Ammannati, Bartolommeo, 2
Andrea del Castagno, 5, 32–33, 47, 54–55, 59, 75, 78, 111
Andrea del Sarto, 4, 54–55, 67, 72, 78, 96, 113
Angelico, Fra Giovanni, 4, 5, 42, 43, 105, 106
Aretino, Pietro, 83–84
Ariosto, Lodovico, 118
Arnolfo di Cambio, 44, 86, 101, 102, 103
Aspertini, Amico, 54, 114
Austen, Jane, 41
Avveduto dell'Avveduto, 57

Baccio d'Agnolo, 56, 85
Baccio da Montelupo, 87
Bacchiacca, 67
Balzac, Honoré de, 6, 7, 109–10
Bandinelli, Baccio, 4, 14, 43, 47–48, 102, 103, 111
Bandinelli, Clemente, 43
Barile, Giovanni, 53
Barocchi, Paola, 117
Bartolommeo della Gatta, 90

Bartolommeo della Porta, Fra, 42, 68, 87, 114
Battiferri, Laura, 73
Baudelaire, Charles, 62
Bellini, Gentile, 69
Bellini, Giovanni, 69
Bellini, Iacopo, 43, 69
Bellori, Giovanni Pietro, 3
Bembo, Pietro, 118
Benedetto da Maiano, 42
Benedetto da Rovezzano, 42
Berenson, Bernard, 15–16, 110
Berna da Siena, 86
Bernardino, San, 90, 91
Bernardo del Buda, 55
Bibbiena, Bernardo Dovizi da, 52, 72
Boase, T. S. R., 117
Boccaccio, Giovanni, 4, 10–11, 14, 49, 52, 91, 109, 115, 118
Booth, Wayne, 119
Borgherini, Pierfrancesco, 67, 68, 74, 76
Botticelli, Sandro, 19–20, 25, 53, 56, 74, 106
Bramante, Donato, 53
Braudel, Fernand, 109
Bronzino, Agnolo, 33, 69–70, 76
Browning, Robert, 4, 7, 43, 72
Brunelleschi, Filippo, 5, 26, 42, 44, 55, 56, 80, 104, 113, 114
Bruni, Leonardo, 90
Bruno di Giovanni, 14–15, 16, 17, 23
Buffalmacco, Buonamico, 14–15, 16, 17–18, 19, 20–24, 25–26, 27, 28, 29, 30–31, 52, 54, 55, 59, 86, 97, 109, 114

Bull, George, 117
Burckhardt, Jakob, 81, 82, 83, 110
Burton, Robert, 115

Calandrino, 23, 52
Calvino, Italo, 51
Caparra (Niccolò Grosso), 49, 81, 114
Caro, Annibale, 112
Carota, 43
Castiglione, Baldassare, 16–17, 80, 81, 112, 115, 118
Cather, Willa, 7
Cavallini, Pietro, 105
Cellini, Benvenuto, 14, 48, 84, 100, 101, 103, 105, 118
Charles V, 83
Chaucer, Geoffrey, 4, 115
Chigi, Agostino, 30, 35, 113, 114
Cimabue, 3, 4, 8, 50, 85
Clark, Kenneth, 62, 117
Clement VII, Pope, 43, 83, 106
Cola dell'Amatrice, 71–72
Condivi, Ascanio, 13, 100, 103
Correggio, 63
Cronaca, 48, 102, 103
Curtius, E. R., 40

Daddi, Bernardo, 89
Daniele da Volterra, 95
D'Annunzio, Gabriele, 6
Dante Alighieri, 8–10, 11, 30, 41, 46, 49, 65, 74–75, 81–82, 84, 108, 109, 110, 115, 118
Della Porta, Giambattista, 118
Della Porta, Guglielmo, 95
Dello Delli, 55, 98–99
Demosthenes, 92
Desiderio da Settignano, 42, 54
Dickens, Charles, 115
Diderot, Denis, 115
Donatello, 5, 26, 28, 33, 48, 52, 54, 55, 61, 80, 113, 114
Donne, John, 40
Domenico Veneziano, 5, 32, 33
Duccio, 8, 9

Eliot, George, 6
Ennius, 60
Erasmus, 40, 115, 119

Farinata degli Uberti, 75
Farnese, Alessandro, 112, 115

Feltrini, Andrea di Cosimo, 59
Flora, Francesco, 118
Franciabigio, 72
Freedberg, Sydney, 58
Freud, Sigmund, 4, 6, 62
Frye, Northrop, 119

Gaddi, Gaddo, 86, 104
Gaddi, Taddeo, 31, 56
Gambara, Veronica, 73
Gentile da Fabriano, 69, 85
Gherardi, Cristofano, 28–29, 56–57, 95
Ghiberti, Lorenzo, 53, 93
Ghirlandaio, David, 24–25, 114
Ghirlandaio, Domenico, 78, 104
Ghirlandaio, Ridolfo, 102, 103, 113
Gibbon, Edward, 120
Giocondo, Francesco del, 63
Giorgione, 43, 58, 81
Giottino, 43, 86, 88
Giotto, 3, 4, 8, 10–12, 17, 44, 45, 52, 80, 82, 85, 110–11
Giovanni da Ponte, 42
Giovanni da Udine, 58, 94, 114
Giovio, Paolo, 112
Girolamo dai Libri, 43
Giulio Romano, 43, 51, 80, 94, 113
Goncourt, Edmond and Jules, 7
Gozzoli, Benozzo, 59
Graffione, 49–50
Granacci, Francesco, 67, 68
Guicciardini, Francesco, 107, 109
Gutenberg, Johann, 55

Hawthorne, Nathaniel, 7
Henry VIII, 83
Homer, 74, 120

Iacone, 10, 97, 98, 114
Iacopo di Casentino, 78, 86, 89
Isidore of Seville, 40

James, Henry, 7
Jonson, Ben, 119
Joyce, James, 41, 86, 115
Julius II, Pope, 4, 6, 22, 53
Julius III, Pope, 54

Kallab, Wolfgang, 118
Kafka, Frans, 7

Lappoli, Giovanni Antonio, 94
Leo X, Pope, 61, 78, 106
Leonardo da Vinci, 4, 18, 35, 60–65, 80, 82
Lessing, Gotthold Ephraim, 15
Lippi, Filippino, 42, 104
Lippi, Filippo, 4, 5, 42, 85, 107, 111
Lippo Fiorentino, 46–47, 78, 86
Livy, 73, 74, 99
Lomazzo, Giovanni Paolo, 60
Longhi, Roberto, 8, 118
Lorentino di Andrea d'Arezzo, 90–91, 114
Lorenzetti, Pietro, 86, 87
Lorenzo di Bicci, 55, 114
Lorenzo Monaco, 78, 86
Lucian, 115

Machiavelli, Niccolò, 4, 73–74, 107, 109, 118
Mann, Thomas, 7
Mantegna, Andrea, 111
Marchionne, 86
Margaritone, 86
Marsuppini, Carlo, 90
Marzi, Tommaso, 90
Masaccio, 26, 43, 80, 85, 104, 111
Masolino, 43
Maugham, William Somerset, 7
Mazzoni, Giulio, 13
Medici, Duke Alessandro de', 64, 96, 100, 101, 106
Medici, Cosimo de' (il Vecchio), 26, 28
Medici, Duke Cosimo de', 3, 14, 28, 64, 76–77, 81, 87, 95, 96, 101, 102, 103, 104, 105, 107, 108
Medici, Giuliano de' (il Magnifico), 16
Medici, Lorenzo de' (il Magnifico), 41–42, 45, 49, 53, 64, 92, 97, 113, 114, 115
Medici, Lorenzo di Pier Francesco de', 100–101
Medici, Ottaviano de', 96, 100, 106
Medici, Piero de', 106
Melozzo da Forli, 59
Menighella, 13
Merejkowski, Dmitri, 6
Michelangelo, 3, 4, 10, 19, 22–23, 26–27, 29, 30, 34, 37, 42, 47, 60, 72, 80, 81, 82, 85, 94, 96, 97, 100, 103, 104, 106, 111, 113, 114, 117
Michelozzo di Bartolomeo Michelozzi, 78, 101–2, 103, 105–6
Milanesi, Gaetano, 32

Mini, Antonio, 13
Mirollo, James V., 118
Mitchell, Barbara, 118
Molza, Francesco Maria, 112
Montaigne, Michel de, 84, 115, 119
Montorsoli, Giovanni Angelo, 94
More, Thomas, 40, 119
Morto da Feltro, 58–60
Mosca, Simone, 95, 96

Nanni di Banco, 113
Nanni di Prospero delle Corniuole, 57
Nardi, Giuliano, 90
Nencioni, Giovanni, 118
Niccolò Aretino, 89, 90
Nicolas of Cusa, 119
Nunziata, Toto del, 31

Pacioli, Luca, 41
Palla, Giovanbattista della, 70–71, 75, 79
Parri Spinelli, 9–10, 45–46, 47, 62, 89, 90
Pater, Walter, 7, 35, 62, 65
Paul, Saint, 4
Perino del Vaga, 43, 94, 95, 99, 100, 114
Perugino, Pietro, 53, 78, 85
Peruzzi, Baldassare, 35, 43, 94
Petrarch, 35–39, 46–47, 60, 63, 65, 82–83, 84, 89, 118
Petronius, 115
Piccinino, Niccolò, 90
Pierino da Vinci, 42
Piero della Francesca, 41, 42, 91
Piero di Cosimo, 4, 6, 83, 114
Piloto, Giovanni, 98
Pinturicchio, Bernardo, 74
Pippo del Fabbro, 34
Pisano, Giovanni, 88
Pisano, Nicola, 88
Pitti, Miniato, 98
Pliny the Elder, 11
Plato, 4, 115
Poliziano, Angelo, 11, 118
Pollaiuolo, Antonio, 53
Pontormo, Iacopo, 33, 52, 65–71, 72, 76–77, 83, 107, 108
Proust, Marcel, 7, 86, 110–11

Rabelais, François, 17, 50–51, 81, 84, 115, 119
Ragghianti, Carlo, 118

Raphael, 4, 38–39, 43, 80, 104, 106, 113, 114
Riccò, Laura, 118
Rilke, Rainer Maria, 6
Ronsard, Pierre de, 119
Rosselli, Donato, 90
Rossellino, Antonio, 42
Rossi, Properzia de', 73
Rosso Fiorentino, 20–21, 43, 96
Rouchette, Jean, 118
Rustici, Giovan Francesco, 113

Sacchetti, Franco, 11, 14, 17, 18, 19, 30, 31,
 52, 89
Salviati, Francesco, 76, 79, 82, 94, 95
San Gallo, Aristotile da, 43, 95, 97, 99–101
San Gallo, Giovanni Battista (il Gobbo), 43
San Gallo, Giuliano da, 41, 45
Sannazaro, Iacopo, 40, 118
Sansovino, Iacopo, 34
Santi, Giovanni, 39
Savonarola, Girolamo, 102
Schlosser, Julius von, 85, 118
Sebastiano del Piombo, 43, 81, 114
Shakespeare, William, 40
Shandy, Walter, 40
Signorelli, Luca, 53, 93, 94
Simone Martini, 31, 36, 37, 60, 83, 89
Soderini, Pietro, 64
Sodoma, 30, 48
Spenser, Edmund, 119
Spinello Aretino, 18–19, 45–46, 86, 89, 90
Starnina, Gherardo, 55
Stefano Fiorentino, 20, 85
Sterne, Laurence, 115
Stevenson, Robert Louis, 40
Strozzi, Giovan Battista, 37, 60
Suetonius, 109
Summers, David, 118

Taddei, Taddeo, 113
Tafi, Andrea, 17–19, 95

Tarlati da Pietra Mala, Guido, 88
Tarlato da Pietra Mala, Piero, 88–89
Tasso, Battista del, 53, 95, 97, 102
Tasso, Torquato, 118
Thucydides, 74, 99
Tintoretto, Iacopo, 14
Titian, 35, 51, 94
Tolomei, Claudio, 112
Tommasuolo, Beato, 90
Topolino, 13, 48
Torbido, Francesco, 54
Torrigiani, Pietro, 47, 53
Tosini, Michele, 57
Traditi, Piero, 90
Tribolo, Niccolò, 48, 93, 95, 101, 102

Uccello, Paolo, 6, 24, 25, 51–53, 59, 72, 113

Vasari, Antonio, 93
Vasari, Lazzaro, 87, 89, 91–92
Veltroni, Stefano, 57
Vere de, Gaston Du C., 117
Verrocchio, Andrea, 62
Vespasiano da Bisticci, 26
Vico, Enea, 43
Vincenzo da San Gimignano, 43
Virgilio Romano, 43
Visino, 114
Vittoria, Alessandro, 53
Voragine, Iacobus, 40

Wazbinski, Zygmunt, 118
Winckelmann, Johann Joachim, 3
Wordsworth, William, 40, 86

Xenophon, 115

Zola, Emile, 6, 7
Zuccaro, Taddeo, 72
Zoppo, 43